IMAGES
of America

SANFORD *and*
LEE COUNTY

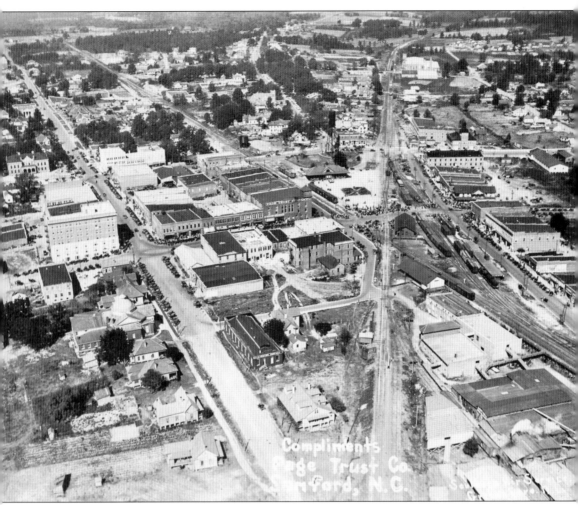

This May 1925 aerial photograph of Sanford shows the recently completed Wilrik Hotel and a vacant lot where construction has not yet begun on the Carolina Hotel. The photograph was sponsored by Page Trust Company, a financial institution located in the Commercial Building. Page advertised capital of $250,000 during this period, but it would not survive the coming Depression. (From the collection of Jimmy Haire.)

ON THE COVER: Sanford city leaders show off their new 1939 fire engine in front of city hall on Charlotte Avenue. Pictured here are, from left to right, alderman Stacey Love, alderman J. T. Ledwell, alderman E. M. Underwood, Mayor Warren R. Williams, and alderman E. W. Fields. Not pictured are alderman W. R. Makepeace and town clerk Harvey Kennedy. (From the collection of the Railroad House Historical Association.)

IMAGES
of America

SANFORD *and* LEE COUNTY

Jimmy Haire and W. W. Seymour Jr.
on behalf of the
Railroad House Historical Association, Inc.

ARCADIA
PUBLISHING

Published by Arcadia Publishing
Charleston SC, Chicago IL, Portsmouth NH, San Francisco CA

Printed in the United States of America

Library of Congress Catalog Card Number: 2006926512

For all general information contact Arcadia Publishing at:
Telephone 843-853-2070
Fax 843-853-0044
E-mail sales@arcadiapublishing.com
For customer service and orders:
Toll-Free 1-888-313-2665

Visit us on the Internet at www.arcadiapublishing.com

The authors would like to dedicate this book to all the folks in Sanford and Lee County who have enjoyed our historical talks and television programs over the years.

CONTENTS

ACKNOWLEDGMENTS

The authors would like to thank a number of persons who have helped in the preparation of this book. The Railroad House Historical Association, Inc., officers and directors have provided research support. Pres. Worth Pickard, Vice Pres. Jane Barringer, recording secretary Rebekah S. Harvey, corresponding secretary Marty Stevens, treasurer Joan Womble, museum curator William M. Freeman, and directors Oliver Crawley, R. V. Hight, Joe Lawrence, Edwin Patterson, and Hal T. Siler have willingly tackled research tasks. Howard Auman, Robert Brickhouse, Tommy Bridges, Ruth B. Gurtis, John Porter, Frances Warner, Sam Womble, and Glenn York enthusiastically supported us with their expertise in the history of the county. We would also like to thank the many persons whom we contacted about church histories and other research topics.

Most of the photographs and postcards in this book come from the collections of Jimmy Haire, the Railroad House Historical Association, Inc., and W. W. Seymour Jr. A few photographs and postcards provided by other persons and institutions are credited in the captions. Special appreciation is given to the Jonesboro Historical Society.

We also wish to thank our acquisitions editor at Arcadia, Maggie Bullwinkel, for her assistance in helping us to navigate the daunting task of preparing a book of historical photographs.

Finally we would like to thank our families and coworkers for their patience and support during the past few months.

Our main reference was the 1995 Railroad House Historical Association, Inc., book *The History and Architecture of Lee County, North Carolina* by J. Daniel Pezzoni. We also consulted the Sanford centennial history book and *The Sanford Herald* Centennial Edition (both 1974) and *Broadway, Past and Present* (1996). Much of Jimmy Haire's historical information comes from conversations with longtime residents Leonard Ascough, Harvey Kennedy, Bessie Neal, and Garland Perry during their lifetimes.

INTRODUCTION

Located in the center of North Carolina, the Lee County area has been a transportation crossroads for over 200 years. In the early days of North Carolina, Scottish settlers and others used the Deep and Cape Fear Rivers for transporting goods and commerce between the North Carolina coast and the interior of the state.

The largest coal deposits in the southern United States are located in the northwestern area of Lee County. In the 1850s, the miners looked to add the northeastern United States as a market and saw rail transport as the best option. The Civil War interrupted these plans.

After the war, the North Carolina General Assembly authorized the building of a railroad between Raleigh and Columbia, South Carolina. Where the line met an existing east-west line, the town of Sanford sprang up. The town was named in honor of Col. Charles O. Sanford, who was the engineer in charge of building the Raleigh-to-Columbia line.

The railroad constructed a depot and home for the first rail agent in 1872, and the town was chartered in 1874. That home for the rail agent exists today as the Railroad House and is the home of a local history museum.

In 1907, the people of Sanford and neighboring Jonesboro wanted to form their own county, and on March 31, 1907, the North Carolina General Assembly chartered Lee County as the 98th county in North Carolina.

When the automobile came into widespread usage during the early part of the 20th century, U.S. Highway 1 was built from Maine to Florida, and this major highway came right through the middle of Sanford. During the period of the 1920s, 1930s, 1940s, and 1950s, countless travelers passed through Sanford on their way to or from Florida, and numerous hotels, motels, and tourist homes sprang up along the route. During this period, postcards were created to enable those passing through town to write home and tell of their travels.

This book will explore what Sanford and Lee County were like from the late 19th century to the 1970s. The first chapter will look at the early years of Sanford until 1924. The second chapter will explore the years 1924 to 1945, a period of dynamic growth and change for the town. The third chapter will feature photographs of Sanford after World War II. Other chapters will look at Jonesboro, places of worship, food and lodging, and Sanford's neighbors in Lee County.

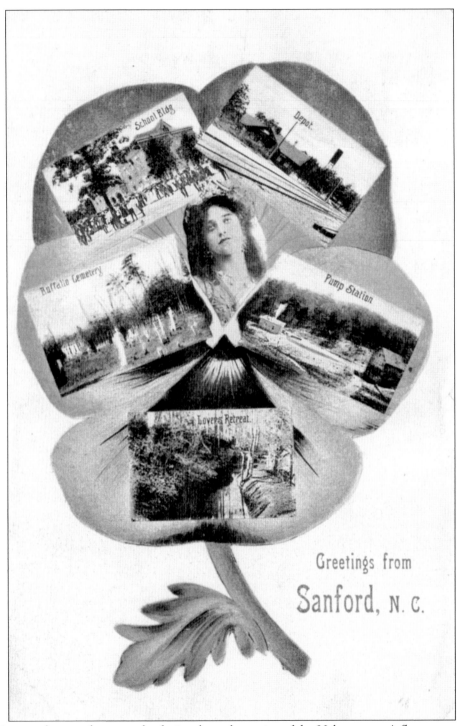

This type of postcard was popular during the early portion of the 20th century. A flower was used to show multiple scenes from Sanford. Each scene was available as a separate postcard. Scenes included are, clockwise from top left, Sanford School Building, Sanford Depot, Pump Station, Lovers Retreat, and Buffalo Cemetery. (From the collection of Jimmy Haire.)

One

SANFORD
The Early Years

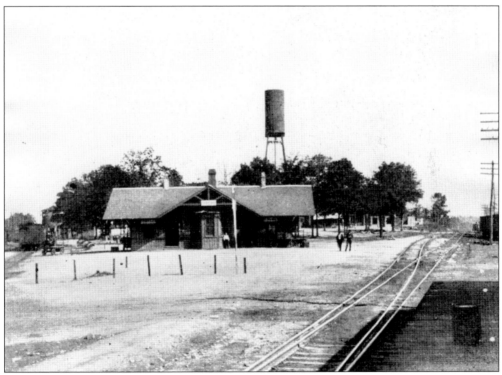

Sanford Union Passenger Depot was the first depot built in the new town. It was constructed along with the Railroad House in 1872 as early buildings in the fledgling community. The depot was built to serve two railroad lines, one on each side. Sanford was not incorporated until February 11, 1874. At that time, it had a population of only 200 persons. (From the collection of Jimmy Haire.)

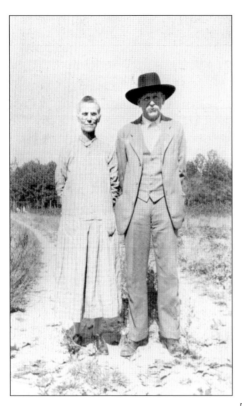

A map of 1850 North Carolina will not show Sanford or Jonesboro. The closest listing to these future towns was a place called Rollins Store. Thomas Rollins was appointed postmaster of the Rollins Store Post Office in 1841. He is shown with his wife in this photograph. Rollins Store was located southeast of the area that would develop as Jonesboro, approximately where the Highway 87 South car dealerships are located. The post office would change its name to Jonesboro in 1865 and Sanford in 1872. (From the collection of the Railroad House Historical Association.)

Although a photograph of Col. C. O. Sanford could not be located, there is a photograph of Sanford's first mayor. W. T. Tucker was the first depot agent for the Raleigh and Augusta Air Line Railroad in Sanford. He and his wife, Inder, moved into the Railroad House in 1872, and he was named mayor in 1874. Inder started the first school in town, the Sanford Institute. Classes were held in the Railroad House. (From the collection of the Railroad House Historical Association.)

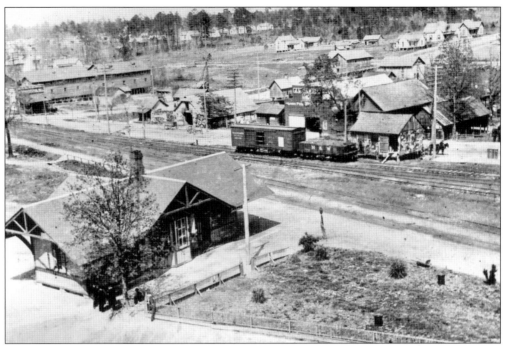

This photograph was taken from the top of the Commercial Building between 1901 and 1905. It offers a stunning view of the depot area, Chatham Street, and East Sanford during this early period in the history of the town. The city hall building had not been built yet. (From the collection of the Railroad House Historical Association.)

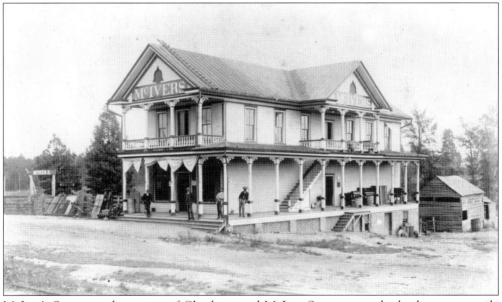

McIver's Store, on the corner of Chatham and McIver Streets, was the leading mercantile emporium in the early years of the town. It began operation in 1873 and by 1883 was able to build the beautiful building shown here. It was known as the "largest general store in Moore County." Over the years, the building had many uses, and it eventually was demolished in 1932. (From the collection of the Railroad House Historical Association.)

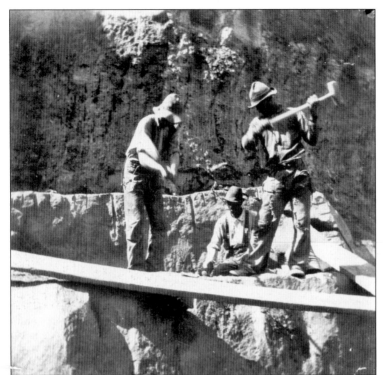

Three workers are shown splitting a large piece of brownstone in the quarry of the Aldrich Brownstone Company in 1897. R. E. Carrington Sr. was the manager of this operation. The brownstone was sent all over the eastern part of the country. The quarry was located just south of Sanford, reportedly near the present location of Central Carolina Hospital. (Courtesy of Elizabeth Carrington O'Connell.)

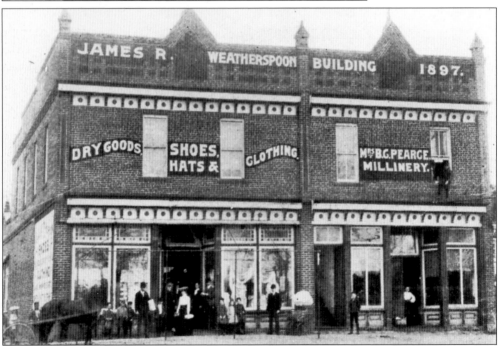

The James R. Weatherspoon Building was built in 1897 at the corner of Carthage Street and Hawkins Avenue, across the street from the present location of the Railroad House. It served the community for many years with a variety of retail businesses. It was reportedly torn down in 1940 to build a service station. (From the collection of the Railroad House Historical Association.)

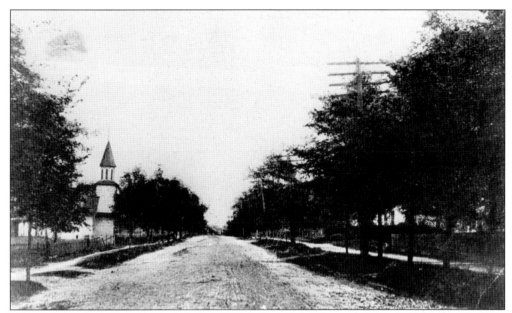

When Colonel Sanford learned that the new town was to be named for him, he stated, "I am flattered that you are naming the town after me. I hope that you will consider naming the most prominent street after Dr. W. J. Hawkins, president of the Raleigh & Augusta Air Line Railroad [and Colonel Sanford's boss]." Hawkins Avenue is shown in this view from the late 1890s. The Sanford Presbyterian Church, built in 1894, is shown on the left. (From the collection of Jimmy Haire.)

This 1890 view of South Steele Street shows the Steele Street Methodist Church. The building in the right foreground is the Farmers Alliance Exchange. It was located on the corner of Steele and Wicker Streets, next to the residence of T. R. Moffitt. A Bible class at the church was named for Mr. Moffitt, and the class is still in existence today. (From the collection of the Railroad House Historical Association.)

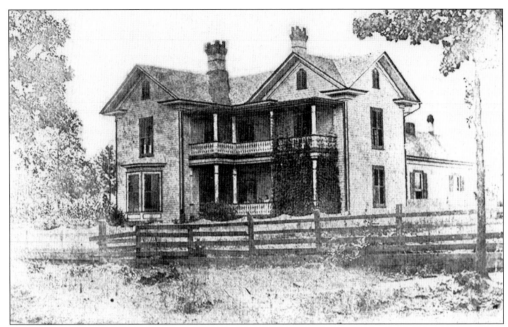

The S. D. Jones house was located on Carthage Street across from where the Temple Theater is located. This house was moved in 1918 to a site on Endor Street (known today as Horner Boulevard), and it was demolished in 1958. Mr. Jones built and operated a "store house" near the site of the Sanford Hotel on Moore Street. (From the collection of the Railroad House Historical Association.)

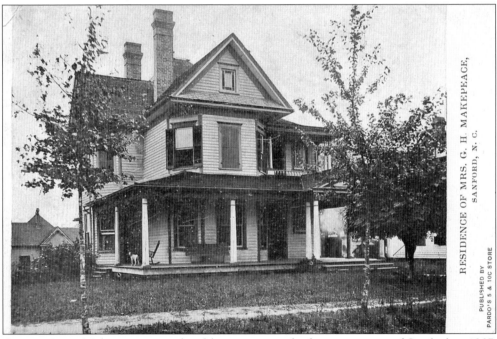

George Henry Makepeace was a local businessman who became mayor of Sanford in 1907. Unfortunately he would die suddenly in July of that year. His house was located at the corner of Gordon and North Moore Streets on the block of what is now the Heins Education Building. (From the collection of Jimmy Haire.)

When it was built in 1910, this house at 306 West Weatherspoon Street was one of only three houses in the exclusive Rosemont Hill area located outside Sanford. The original owner was James C. Williams, the son of the manager of Williams-Belk Company. Henry and Janice Poe owned the house in recent decades. (From the collection of Jimmy Haire.)

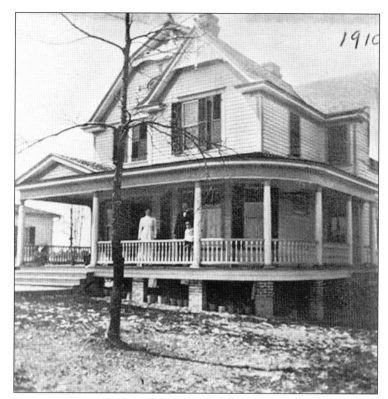

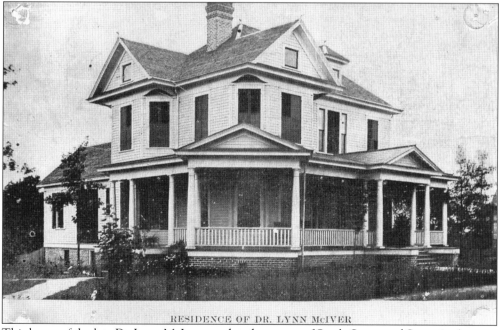

RESIDENCE OF DR. LYNN McIVER

This home of the late Dr. Lynn McIver stood at the corner of Steele Street and Summitt Avenue. It was built by contractor Robert T. Walker prior to 1915. The structure was demolished in 1960, and the site is now used as a parking lot for First Baptist Church. (From the collection of the Railroad House Historical Association.)

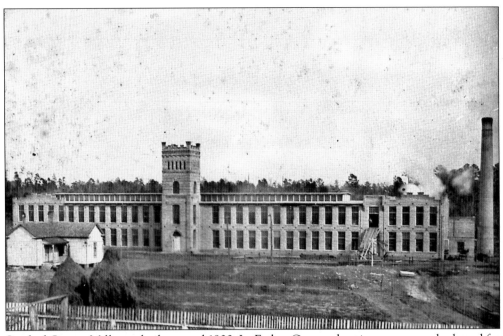

Sanford Cotton Mills was built around 1900. Its Father George sheeting was a popular brand for a number of years. In 1935, it had approximately 250 employees. The mill burned in 2002. (From the collection of the Railroad House Historical Association.)

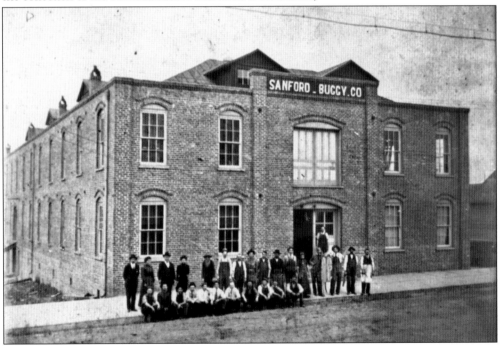

After the formation of Sanford Buggy Company, this building was completed in 1907. It served as a buggy factory until 1922, when it became the home of Brown Buick. During World War II, the third floor was added, and items such as cargo nets were manufactured for the U.S. Navy there. (From the collection of Jimmy Haire.)

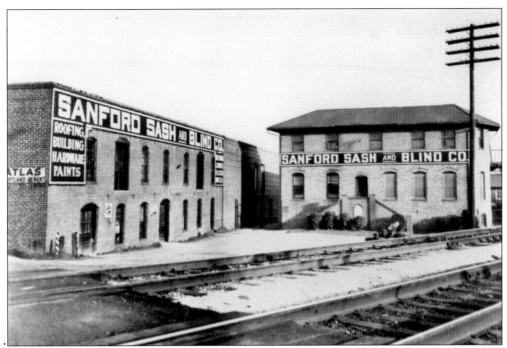

Sanford Sash and Blind Company was founded in 1882. It manufactured dressed lumber, sashes, doors, and blinds from the timber of the area. Maj. John W. Scott and John B. Makepeace organized the company. (From the collection of the Railroad House Historical Association.)

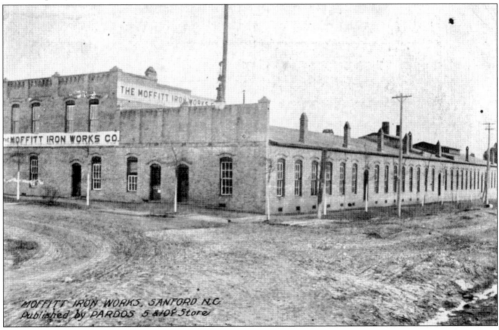

The Moffitt Iron Works Company was organized in 1888. In the early years of the 20th century, this facility was built at the corner of Market Street and Maple Avenue in the heart of the East Sanford industrial area. The building was used by Roberts Company to manufacture textile machinery in later years. (From the collection of Jimmy Haire.)

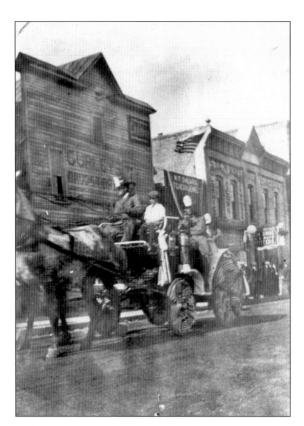

A horse-drawn fire wagon parades down Moore Street in the early 20th century. The wooden structure shown is Gurley Drug Store. The Stein Brothers building was located at the present site of the Sanford Antique Mall. (From the collection of Jimmy Haire.)

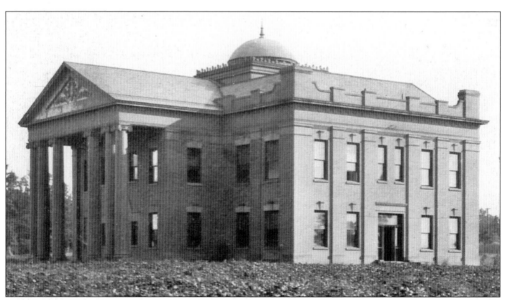

Lee County Courthouse was built in 1908 halfway between Sanford and Jonesboro. The family of Bessie Neal (see page 35) used to go by wagon to the construction site on Sundays as a family outing. For many years, the structure was unique as the only courthouse in North Carolina located outside a city limits. (From the collection of Jimmy Haire.)

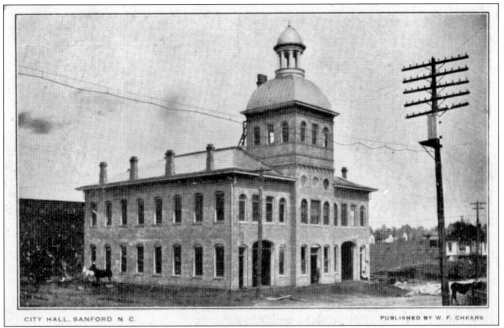

Sanford City Hall was constructed on Charlotte Avenue during 1909 and 1910. The builders were Joe W. Stout and Robert T. Walker. During the early years of the structure, fire horses were stabled in the building. The building was restored by Progressive Contracting Company in 1997 and is now the home of that business, the Sanford Area Chamber of Commerce, and a restaurant. (From the collection of Jimmy Haire.)

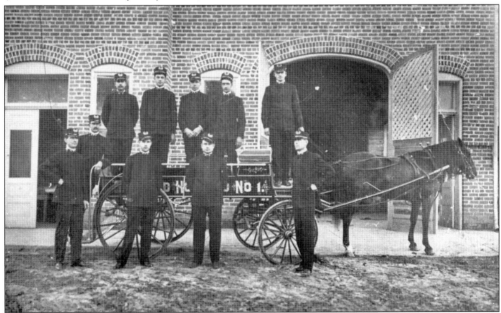

Sanford Hose Company No. 1 is shown in front of city hall in this photograph taken around 1912. From left to right are (first row) Carr Groce, W. R. Makepeace Sr., T. E. King, and Alton Groce; (second row) Toy Matthews, D. L. Seymore, Lee Kelly, Bud Turner, Bernice Cox, and J. R. Kelly. (From the collection of Jimmy Haire.)

19

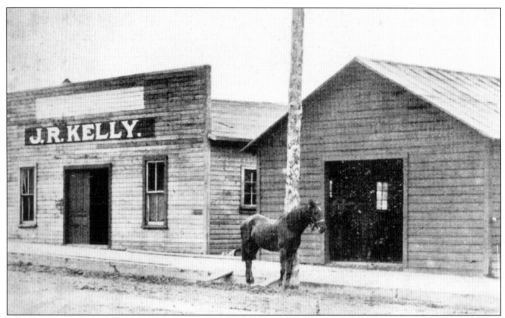

J. R. Kelly's business was located on Charlotte Avenue across the street from where Love's Grocery Store is today. The business reportedly repaired wagons among other services. This photograph was taken prior to the property being sold to J. B. King in 1909. (From the collection of Jimmy Haire.)

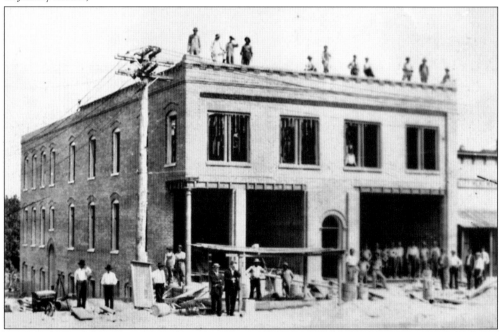

Brick mason John W. Brown built a number of buildings in Sanford in the early years of the 20th century, including the Isaac H. Lutterloh Building in 1909. Dr. Lutterloh's medical office and a drugstore operated by his brother Thomas were located in the building. It is still located on the corner of Chatham and McIver Streets. (From the collection of the Railroad House Historical Association.)

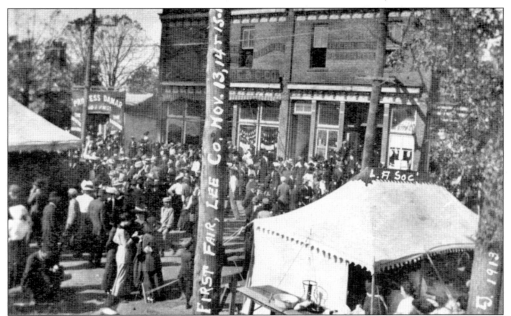

The first Lee County Fair was held November 13–15, 1913, in the area of city hall and the present location of the Railroad House. It was a street carnival with a large crowd. The fair was held yearly until 1919, when the event became more sporadic. The Sanford Lions Club became involved with it in 1935, and the club still sponsors the fair today. (From the collection of Jimmy Haire.)

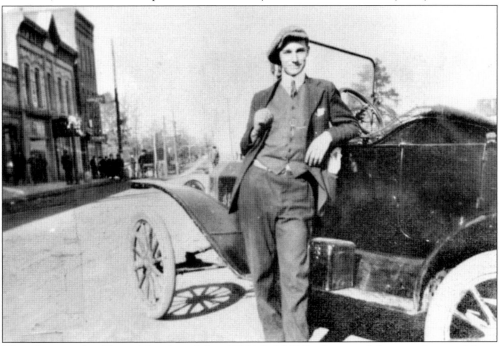

This photograph of Jeter Adcock with his 1916 Model T Ford automobile was taken on Moore Street. Mr. Adcock was from Cumnock and was employed by one of the railroads in Sanford. He later became a rural mail carrier. His son Albert C. Adcock is a well-known Sanford developer. (From the collection of the Railroad House Historical Association.)

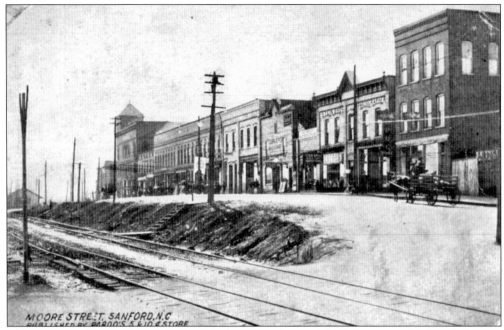

This postcard of Moore Street is postmarked 1914. At this time, both wagons and automobiles were traveling the streets of Sanford. The C. H. Smith Building anchors one end of the block, while the Commercial Building looms at the opposite end. (From the collection of Jimmy Haire.)

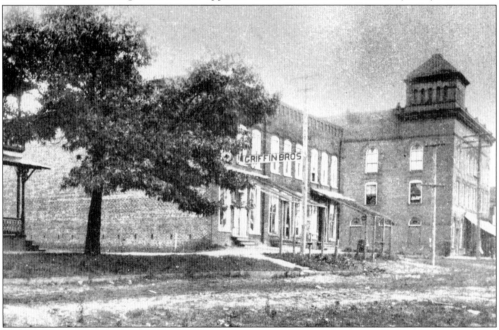

The building at the corner of South Moore Street and Wicker Street with the Griffin Brothers sign was built by early Sanford leader Maj. John W. Scott Sr. in 1887–1888. It was the first brick commercial structure built in Sanford. During its early years, the businesses in the building faced Moore Street. The building is still in use today, but the businesses now face Wicker Street. (From the collection of Jimmy Haire.)

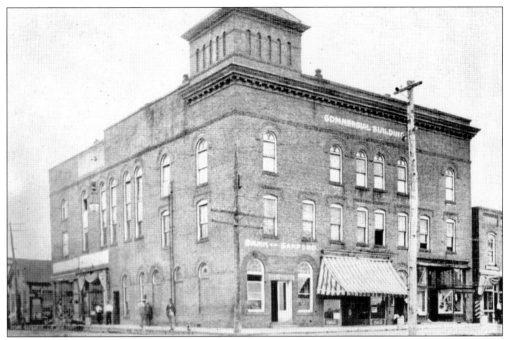

The plans to build the Commercial Building were announced by Major Scott in January 1919. During its existence, the building was home to the Bank of Sanford and the Page Trust Company. The opera house on the upper floors was used for community meetings and performances. The building burned on December 23, 1945. (From the collection of Jimmy Haire.)

This 1916 photograph of the J. Walter McIntosh Store on Wicker Street shows what was probably the last public water trough in Sanford. As motor vehicles became more common, fewer horses and mules were seen on the streets of Sanford. This store was located across the street from where Steve's Barber Shop is now located. (From the collection of Jimmy Haire.)

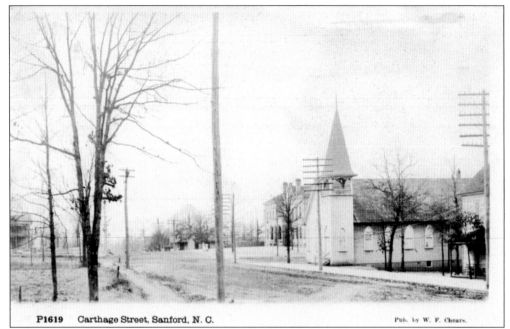

P1619 Carthage Street, Sanford, N. C. Pub. by W. F. Chears.

This postcard of a sparsely developed Carthage Street is from around 1910. The First Baptist Church building at the corner of Carthage and Steele Streets is prominently shown, while the Sanford Graded School can be seen in the distance. (From the collection of Jimmy Haire.)

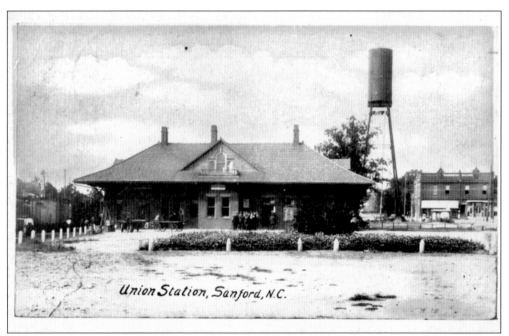

Union Station, Sanford, N.C.

Union Station was a brick passenger depot built about 1910, replacing the earlier wooden depot. This 1923 postcard shows a building that looks very much like what is present in 2006. The Weatherspoon Building can be seen in the background. (From the collection of W. W. Seymour Jr.)

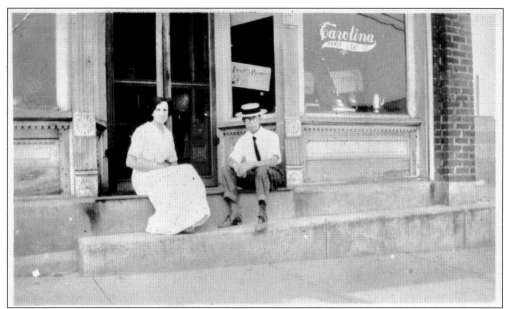

This early photograph of the Carolina Power and Light Company office on Steele Street is from around 1910. Miss Ollie Womble and Fred P. Strong, division superintendent, are shown. The office was located in the area where Restaurant Row is now located. (From the collection of Jimmy Haire.)

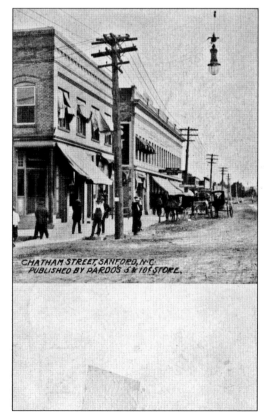

Pardo's 5-and-10¢ Store was a fixture on Chatham Street for several decades. It was located between the Lutterloh Building and Lee Furniture Company. The store sold a number of the postcards featured in this book. It closed for business on June 16, 1927. (From the collection of Jimmy Haire.)

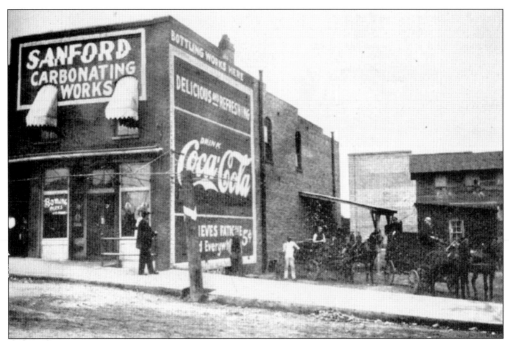

J. R. Ingram set up Sanford Carbonating Works in the former Sanford Express newspaper building on Charlotte Avenue in 1905. This photograph from the 1915 fair catalog shows the business, which would later become the Sanford Coca-Cola Bottling Company. (From the collection of Jimmy Haire.)

Howard-Bobbitt Company operated several Progressive Store supermarkets around Sanford. The store shown here was located at the corner of Charlotte Avenue and First Street. Other stores were located on Steele Street and Wicker Street over the years. (From the collection of Jimmy Haire.)

Stein Brothers was a familiar retail store on Moore Street during the early years of the 20th century. They advertised as clothiers, tailors, and furnishers. They were described in 1913 as "Sanford's Exclusive Ladies Shop." (From the collection of Jimmy Haire.)

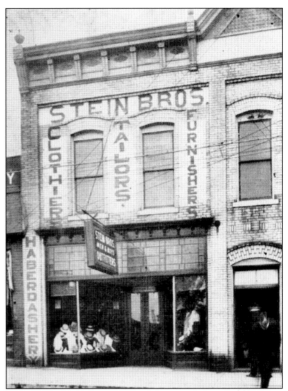

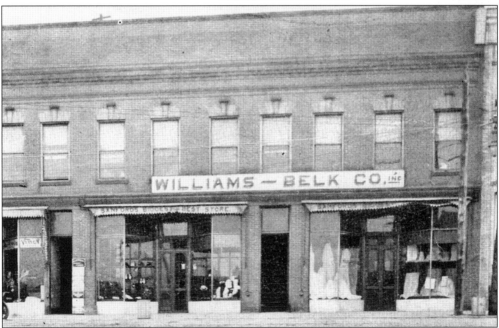

Williams-Belk Company was a retail fixture in Sanford for most of the 20th century. This early photograph shows the slogan "Sanford's Biggest and Best Store." The store began on Moore Street and moved to Steele Street. In the 1980s, it moved to Riverbirch Corner Shopping Center as Belk. (From the collection of Jimmy Haire.)

CHATHAM STREET, SANFORD, N. C.

This postcard of Chatham Street about 1923 was one of a series of cards prepared for W. F. Chears, Jeweler. The scene shows that the former buggy factory was now a dealership that sold Buick automobiles. A lone wagon traveling the street stands in contrast with the automobiles parked nearby. (From the collection of W. W. Seymour Jr.)

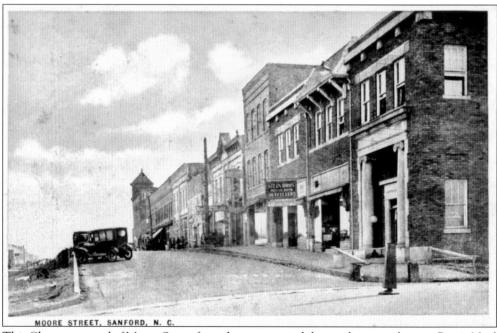

MOORE STREET, SANFORD, N. C.

This Chears postcard of Moore Street from the same period shows a busy retail street. Bessie Neal worked upstairs on this block for many decades and was able to observe the comings and goings in the depot area. (From the collection of Jimmy Haire.)

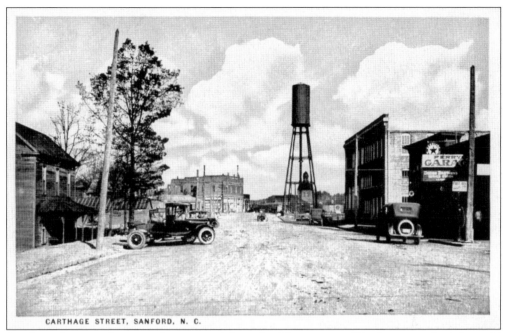

CARTHAGE STREET, SANFORD, N. C.

Carthage Street is shown in this postcard from the Chears series. The house on the left would soon be demolished to make room for the Temple Theater. Garland Perry's garage is on the right. The water tower was located where the Railroad House is now situated. (From the collection of Jimmy Haire.)

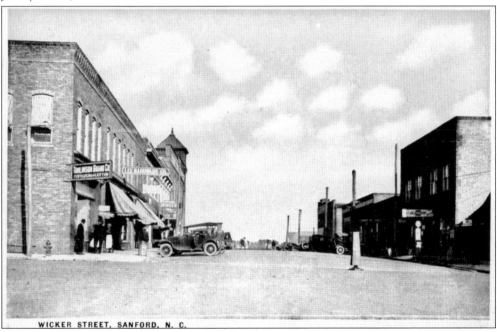

WICKER STREET, SANFORD, N. C.

This final postcard from the Chears series shows Wicker Street. Lee Hardware Company is located on the left. They advertised Tomlinson Guano on the sign above the entrance. In 1937, the site would become a Progressive Store location managed by Sam Womble. (From the collection of W. W. Seymour Jr.)

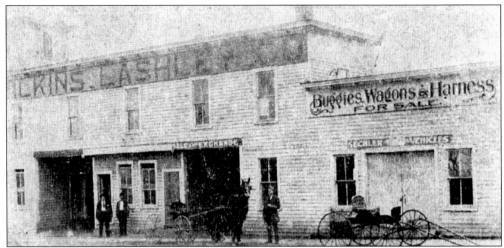

Wilkins Lashley Company was located on Steele Street. A sign on the business advertises "Buggies, Wagons & Harness For Sale." In 1924, Wilkins-Ricks Company started a new project on this lot—the Wilrik Hotel. (From the collection of Jimmy Haire.)

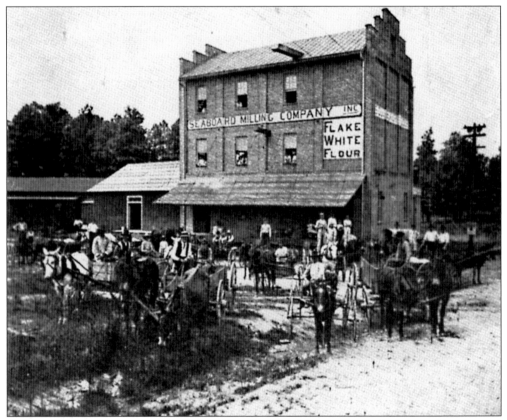

Seaboard Milling Company was built in 1915 and operated for many years by former alderman and county commissioner J. T. Ledwell. In 1931, the Hickory Avenue business produced 125 barrels of flour daily through the labors of its eight employees. (From the collection of Jimmy Haire.)

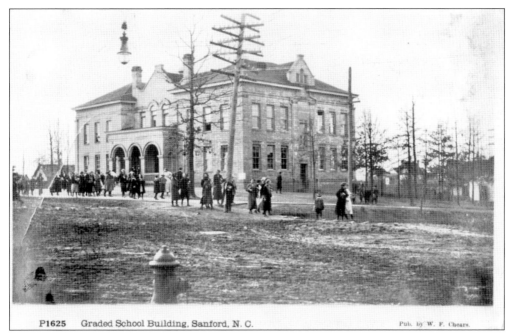

P1625 Graded School Building, Sanford, N. C. Pub. by W. F. Chears.

Sanford Graded School was located at the corner of Carthage and Steele Streets. The private school was built in 1906 and served the community until 1925. The school property was sold at public auction that year. The site would soon become the location of a filling station. (From the collection of Jimmy Haire.)

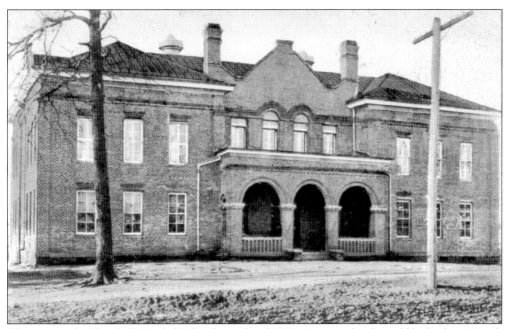

This postcard of Sanford Graded School was dated 1908. A new school would be built on North Steele Street. The 50 graduates of the class of 1925 would receive their diplomas in the new auditorium of Sanford High School in the spring of that year. (From the collection of Jimmy Haire.)

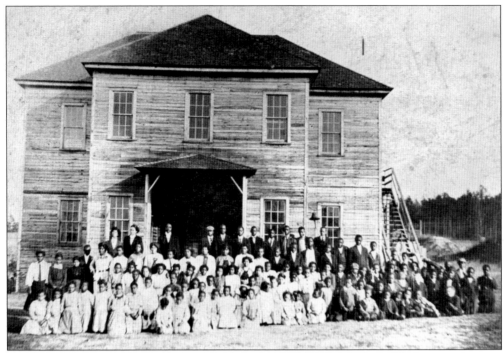

In the early 20th century, a two-story, five-classroom building was built on Washington Avenue. The South Sanford Graded School was a major step forward in the education of the African American children of Sanford. In 1924, a dynamic new principal came to the school. William B. Wicker would make his mark on education in the community. (From the collection of the Railroad House Historical Association.)

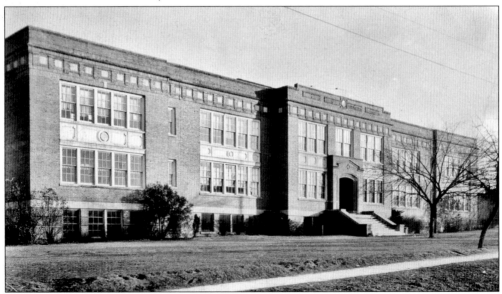

East Sanford Graded School was built in 1916 to serve the industrial and commercial area of East Sanford. The school was renamed McIver School, reportedly to honor well-known North Carolina educator Charles D. McIver. Once the new school on North Steele Street was completed in 1925, the high-school students from McIver attended it. (From the collection of Jimmy Haire.)

Two

SANFORD
1924–1945

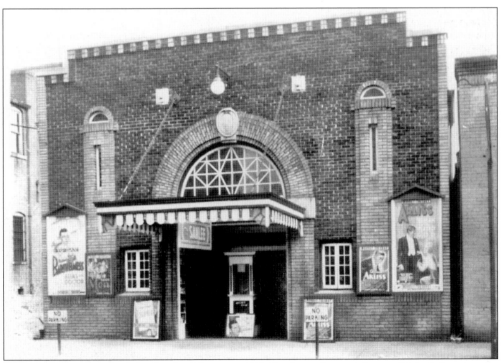

This 1932 photograph of the Sanlee Theater at 212 Carthage Street is Jimmy Haire's favorite one in this book. Originally opening as the L-Ma Theater about 1920, the Sanlee was a place to enjoy "always a good picture, occasionally a great one." Well-known businessman R. P. Rosser took over the operation of the theater in June 1933. (From the collection of Jimmy Haire.)

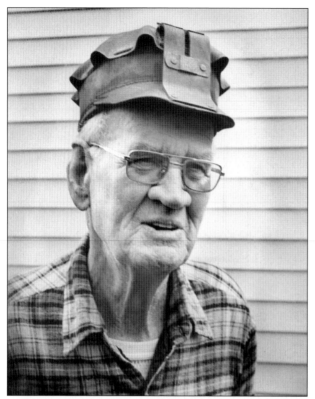

Jimmy Haire gained much of his knowledge of the 1920s, 1930s, and 1940s in Sanford through his conversations with four longtime residents, shown on this page and the next. Leonard Ascough was born in 1906, the son of an English coal miner. Both Leonard and his father worked in the mine at Cumnock, but Leonard is best known for his nearly 50 years of service at King Roofing. He died in 1998. (From the collection of Jimmy Haire.)

Garland Perry's father, Norton H. Perry, ran the store at Egypt and was killed in a robbery there. Garland (below) ran a garage in Sanford prior to securing the Buick dealership for the community. He bought a house on Endor Street during the Great Depression and lived there until his death in 1989. (From the collection of Jimmy Haire.)

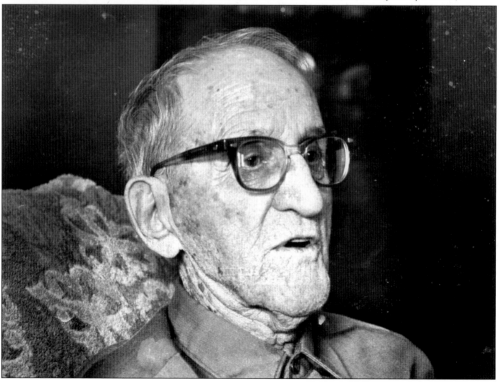

Bessie Kelly Neal was one of those rare persons who lived in three different centuries. She was born on September 24, 1895, and died February 27, 2000, at the age of 104. "Miss Bessie" was a seamstress well into her 90s and was a devoted member of Steele Street (later St. Luke) Methodist Church. (From the collection of Jimmy Haire.)

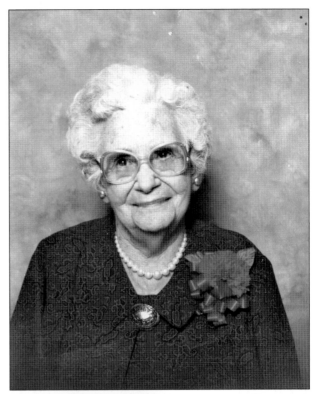

Harvey Kennedy was the son of Egypt Improvement Company's John H. Kennedy. He was born in 1899 and worked at a bank as a young man. He became Sanford's town clerk in 1921 and served faithfully in that position until 1951. He lived in the same house at 503 Summitt Drive from 1925 until his death in 1989. His wife, Irene, was the sister of Bessie Neal. (From the collection of Jimmy Haire.)

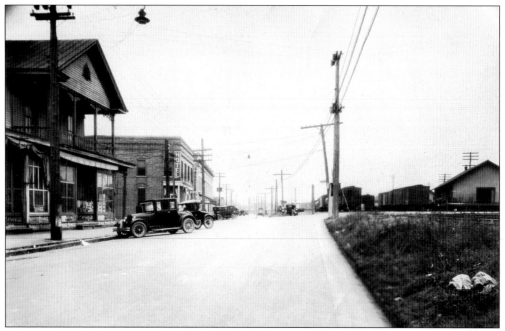

Fred P. Strong was a longtime employee of Carolina Power and Light Company. He was born in England and built an English-style house at 301 North Gulf Street. In the mid-1920s, he made a series of photographs showing the power lines in downtown Sanford. From them, one can experience what it was like to travel the streets of the town during that period. Chatham Street is shown here. (From the collection of Jimmy Haire.)

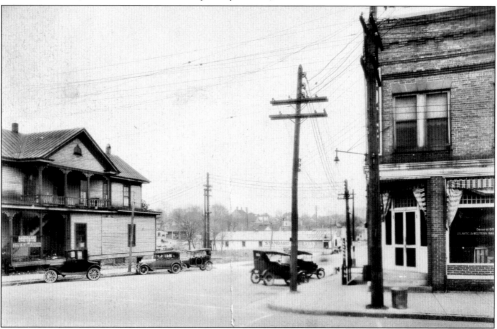

This view of McIver Street at its intersection with Chatham Street shows an aging McIver's Store building. The Lutterloh Building is also shown. During that period, the offices of the Atlantic and Western Railroad were located there. (From the collection of Jimmy Haire.)

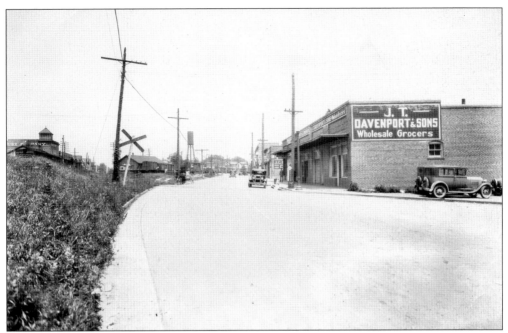

This Strong photograph shows a different view of Chatham Street. J. T. Davenport and Sons was located in the building at the right. The wholesale grocer would continue to expand over the years, and today it is one of Sanford's most successful businesses. (From the collection of Jimmy Haire.)

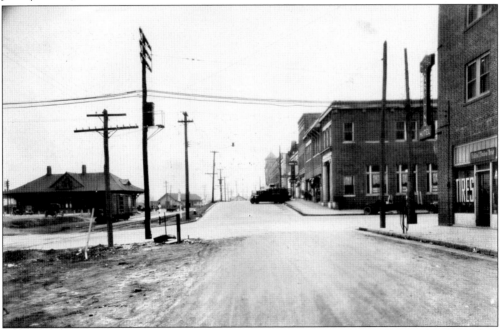

Moore Street in the mid-1920s looks somewhat as it does today. The recently completed Carolina Hotel is on the right, and the depot is prominent on the left of the photograph. The buildings on the corner across Carthage Street from the Carolina Hotel would eventually be torn down to build the Southern Motor Inn. (From the collection of Jimmy Haire.)

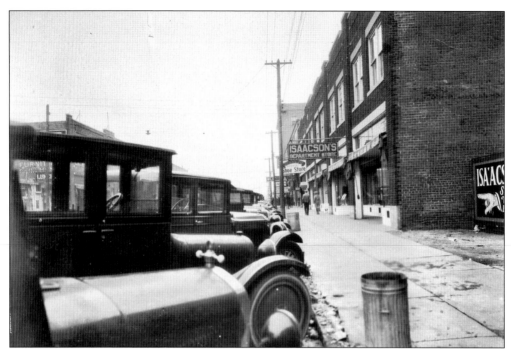

This Strong photograph of Steele Street shows a street full of vintage automobiles and an active business district. Isaacson's Department Store was a popular shopping destination during this period. Wicker's Shoe Store is also shown. (From the collection of Jimmy Haire.)

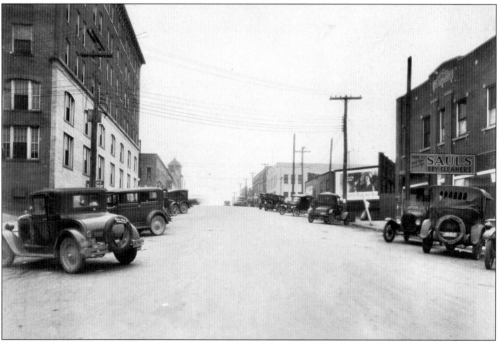

This classic view of Wicker Street shows the Wilrik Hotel on the left. The 1924 Seymore Building on the right is the location of Dossenbach's furniture store in 2006. These two structures were part of a building boom in Sanford that began in 1924. (From the collection of Jimmy Haire.)

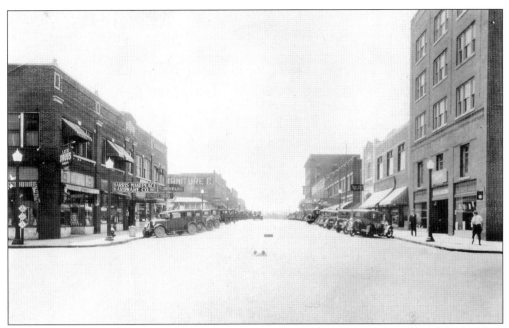

This photograph of Steele Street was taken around 1930. O. P. Makepeace constructed the building on the left in 1924. The Lee Furniture building on the right was built in 1927. The traffic signals are located in the middle of the street. (From the collection of Jimmy Haire.)

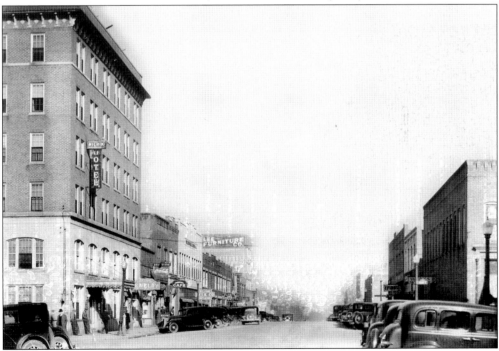

Looking at Steele Street north from Wicker Street during the same time period, some familiar store names stand out. Williams-Belk Company and Isaacson's are on the left, while Efird's Department Store is located on the right. The Lee Furniture building is in the distance. (From the collection of Jimmy Haire.)

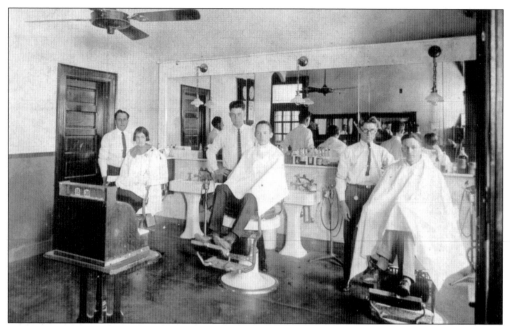

The barber shop in this mid-1920s photograph was located on Wicker Street near the Commercial Building. The barbers pictured are, from left to right, George Watson, Oscar Porter, and Neil Dickens. After the Commercial Building fire of 1945, the shop would move across the street. It is now known as Steve's Barber Shop. (From the collection of Jimmy Haire.)

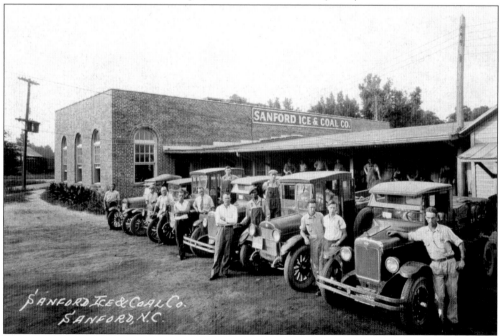

Tom Salmon and John Salmon operated Sanford Ice and Coal Company for many years. The company supplied ice for refrigeration purposes and coal for heating. The distinctive building is still located on Market Street and is the location of Ready Mixed Concrete Company. (From the collection of Jimmy Haire.)

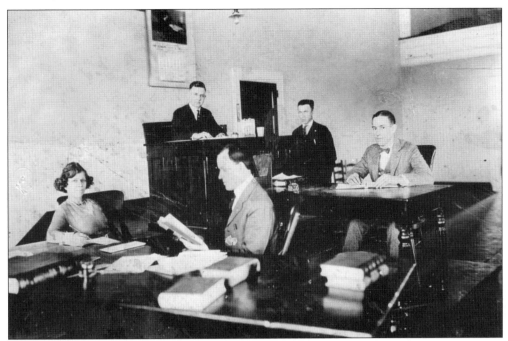

This mid-1920s scene of a courtroom at the Lee County Courthouse shows Judge Lloyd Horton presiding. Seated are solicitor Clawson L. Williams (left) and clerk of superior court Duncan E. "Blue" McIver. Standing next to the judge is Sheriff Landon C. Rosser. This courtroom is still in use today. (From the collection of the Railroad House Historical Association.)

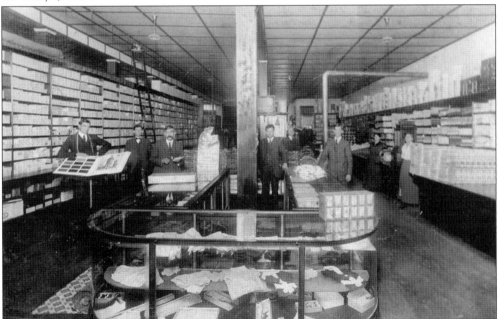

This photograph shows the inside of the Wilkins, Ricks, and Company store when it was located on the west side of Steele Street. Pictured from left to right are G. Howard Oliver, George Brannon, Cary Kelly, Brooks Wicker, John L. Covington, Jeff Johnson, Mary Caudle, and Mamie Brown. (Courtesy of Vivian Oliver Monger.)

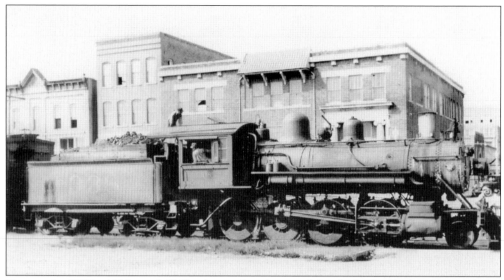

During the 1920s, 1930s, and 1940s, four railroads served Sanford. The Seaboard, Southern, Atlantic Coast Line, and Atlantic and Western Railroads contributed to the large number of trains passing through downtown Sanford. The three buildings on the right shown here would be torn down in 1937 to build the Southern Motor Inn. (From the collection of Jimmy Haire.)

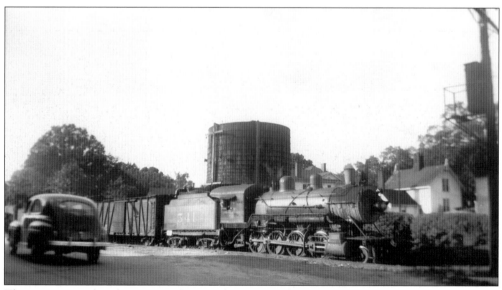

This scene was taken from Moore Street. The water tank for the train was located in what is now the back parking lot of Mrs. Wenger's Restaurant. The house shown is none other than the Railroad House at its original location on Hawkins Avenue. (From the collection of Jimmy Haire.)

Harry P. Edwards, general manager of the Atlantic and Western Railroad, founded the Edwards Railway Motor Car Company in 1917. This plant off Rose Street was built in 1922, and by the middle of the decade, it was in full production of passenger rail cars. During World War II, more than 1,000 persons worked here on war production. (From the collection of Jimmy Haire.)

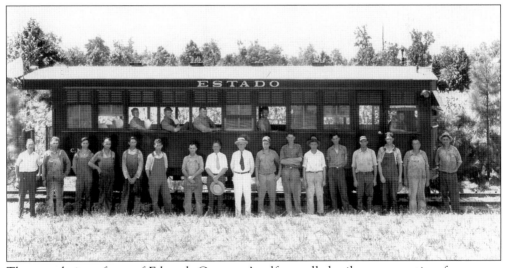

The completion of one of Edwards Company's self-propelled rail cars was a time for a group photograph of the 22 persons who worked on the car. Edwards cars have been used all over the world, and some are still in use in South America. (From the collection of Jimmy Haire.)

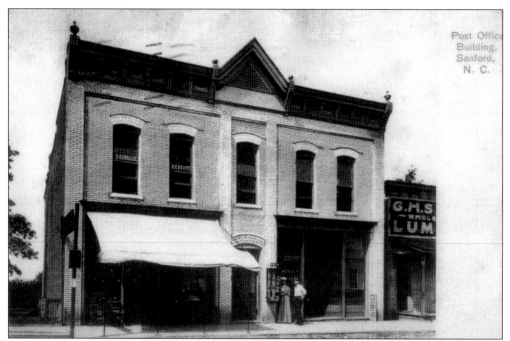

The building pictured here housed Sanford's U.S. Post Office for a number of years up to 1927. It was located on Moore Street, near the Connor H. Smith Building. Although this building is no longer standing, the Smith Building is still in use today as the home of Harris and Company Insurance. (From the collection of Jimmy Haire.)

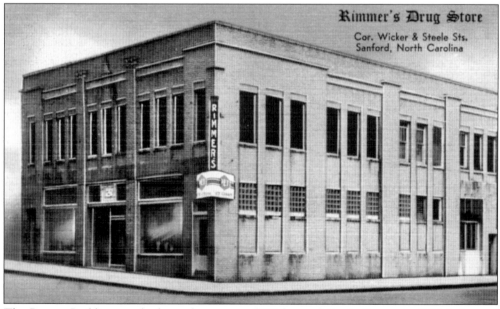

The Bowers Building was built on the corner of Wicker and Steele Streets in 1927. It housed Sanford's post office from 1927 to 1937. The Rimmer's Drug Store space would eventually become Mann's Drug Store. A number of professional offices, including W. W. Seymour's law office and Dr. Worth Byrd's dental office, were located on the top floor of the building. (From the collection of Jimmy Haire.)

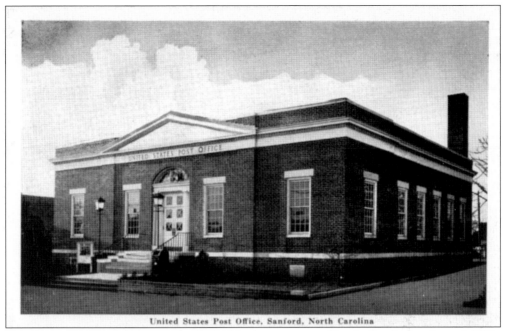

United States Post Office, Sanford, North Carolina

The Works Progress Administration (WPA) built a new post office for Sanford in the mid-1930s. This building served as the post office for the community from 1937 to the mid-1960s. In later years, the building would be used as the federal building and as office space for city and county government. (From the collection of Jimmy Haire.)

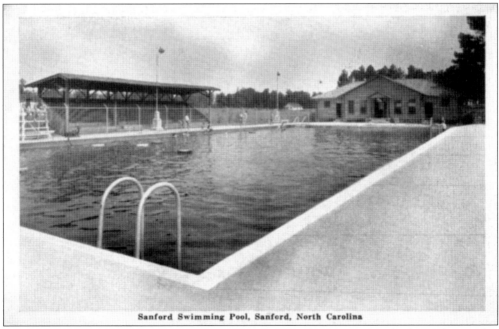

Sanford Swimming Pool, Sanford, North Carolina

The WPA also built the Park Avenue Pool facility shown in this 1941 postcard. The pool opened in June 1935 and was used by generations of residents until it was demolished in the late 1970s. Kiwanis Children's Parkplace now occupies the site. (From the collection of W. W. Seymour Jr.)

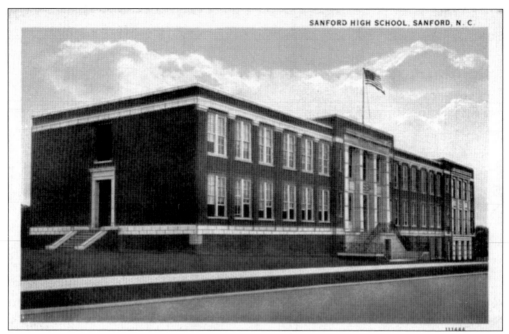

Sanford High School was built in 1925 on North Steele Street. It served as Sanford's high school until 1952, when Sanford Central High School was built on Nash Street. The original school then became Sanford Junior High School. The building is now known as the Lee County Arts and Community Center. (From the collection of Jimmy Haire.)

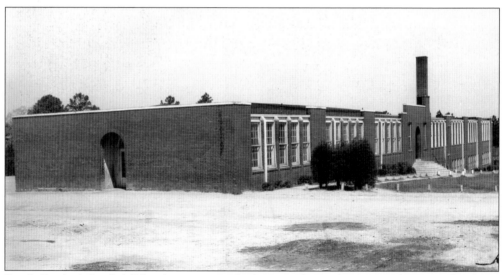

South Sanford Graded School outgrew its facilities in the mid-1920s, and a new school was constructed in 1927 by builder A. Lincoln Boykin. Lee County Training School was renamed W. B. Wicker School in 1954, a fitting tribute to the longtime principal of the school. The facility is in the process of restoration. (From the collection of Jimmy Haire.)

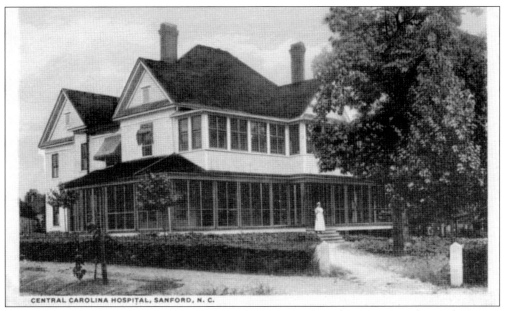

CENTRAL CAROLINA HOSPITAL, SANFORD, N. C.

Central Carolina Hospital was located on the corner of Maple Avenue and Fourth Street. Contractor Robert T. Walker built the structure around 1907. Dr. John P. Monroe and Dr. William A. Monroe operated the facility. It served the community until the construction of the new Lee County Hospital on Hillcrest Drive. (From the collection of Jimmy Haire.)

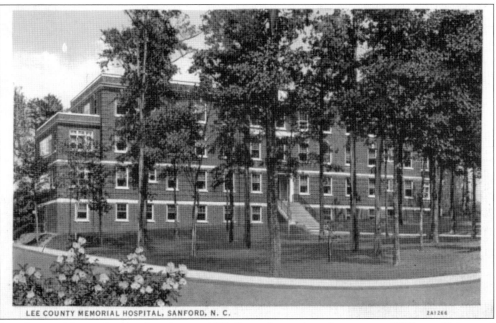

LEE COUNTY MEMORIAL HOSPITAL, SANFORD, N. C.

Lee County Hospital opened in August 1931. It was located on the corner of Hillcrest Drive and Carthage Street. W. W. Seymour Jr. spent the first 15 years of his life living down the street from the facility. This 1937 postcard shows the hospital before a mid-1960s addition. It closed in 1981, and the building became the Lee County Government Center in 1991. (From the collection of W. W. Seymour Jr.)

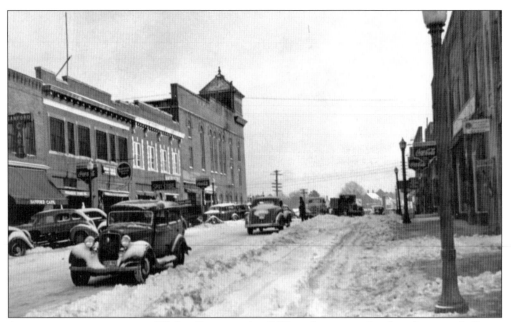

A snowy winter morning on Wicker Street in the 1930s is the setting for this photograph. Some of the businesses on the left side of the street include Sanford Café and Western Auto. Coca-Cola signs above businesses are evident, with no less than four in this scene. (From the collection of Jimmy Haire.)

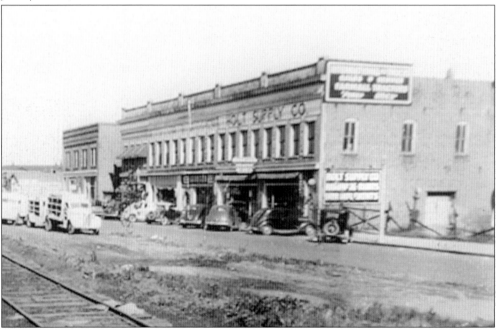

This building on Chatham Street has an interesting history. The site of Lee Furniture until 1927, the building was occupied by Holt Supply Company in this photograph. Holt would eventually move to the corner of Endor and Rose Streets. In later years, Associated Distributors bottled Zimba Cola, Big Boy Cola, and Nesbit Orange soft drinks in the building. (From the collection of Jimmy Haire.)

This view of Carthage and Moore Streets in the 1930s shows the older buildings of Moore Street still in place. Franklin D. Roosevelt would travel down this street in a motorcade cheered by thousands of people during this decade. (From the collection of Jimmy Haire.)

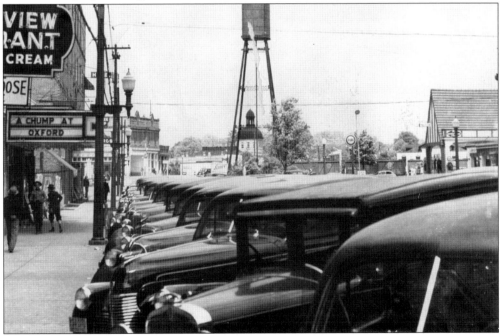

This 1940 view of Carthage Street shows that a Laurel and Hardy movie is playing at the Temple Theatre. The theater was built in 1925 and showed motion pictures until the 1960s. For the past 25 years, it has been a regional performing-arts theater. The water tower was located at the present site of the Railroad House. It was removed in 1954. (From the collection of Jimmy Haire.)

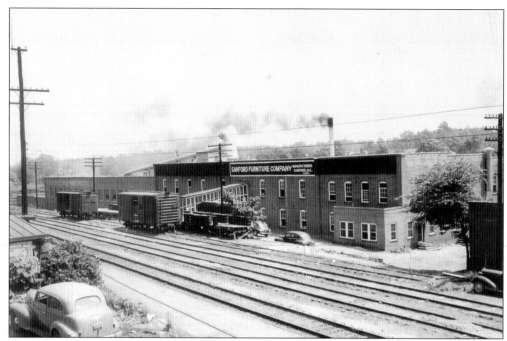

Behind city hall, next to the railroad tracks, sits a manufacturing plant that has had a major impact on the economy of Sanford. J. Fred Von Canon came to Sanford in the 1930s, and the old Fitts-Crabtree factory became Sanford Furniture Company. It was a major employer in the community for decades. (From the collection of Jimmy Haire.)

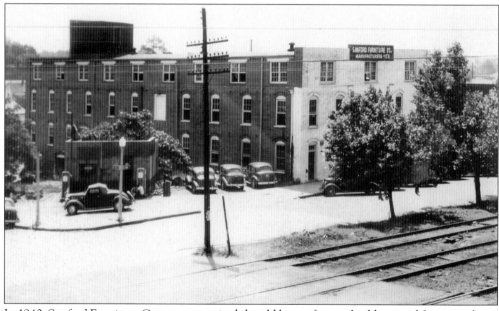

In 1940, Sanford Furniture Company acquired the old buggy factory building, and four years later, the company would add the present third story. The building was used during the early 1940s for war-related manufacturing. After the war, the company returned to making bed frames and headboards. Brothers Gene and Roma Lanier ran the gas station in front. (From the collection of Jimmy Haire.)

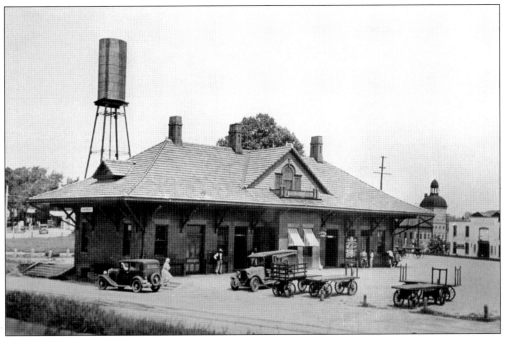

During the 1930s and 1940s, the depot was a bustling place. This 1937 view shows the daily activity associated with the railroad. The trains were an active part of the mail delivery system for decades. Sanford still had substantial passenger service during this period. (From the collection of Jimmy Haire.)

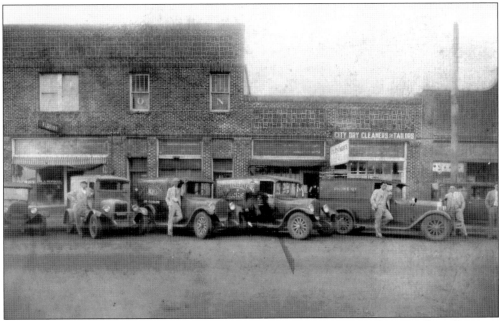

City Dry Cleaners and Tailors was a thriving business on Wicker Street for a number of years in the 1940s and 1950s. The cleaners had a fleet of vehicles and once had the contract to do the laundry for Fort Bragg. The names Porter and Lemmond are associated with the business. (From the collection of Jimmy Haire.)

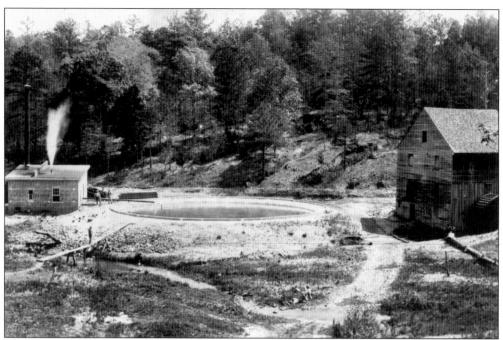

Under the leadership of W. J. Edwards, Sanford built a waterworks on Lick Creek in the early 20th century. Thirty years later, a new facility was built east of the town, and this location was abandoned when a new plant on the Cape Fear River began operation in 1971–1972. The abandoned 1930s site is now San-Lee Park. (From the collection of the Railroad House Historical Association.)

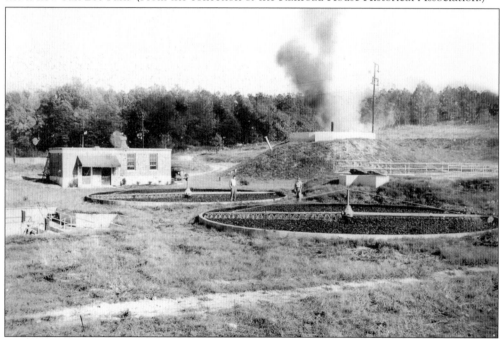

Sanford operated a sewage treatment plant off Spring Lane near the present location of U.S. Highway 1. The plant was closed in the mid-1970s, when a new facility on the Deep River was put into operation. (From the collection of Jimmy Haire.)

Three

SANFORD
After the War

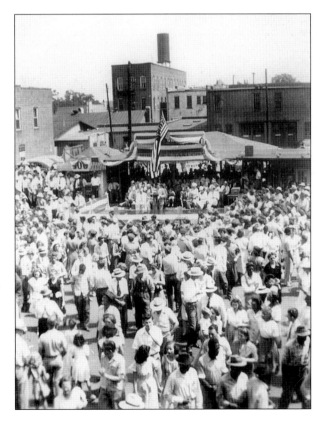

Prior to the construction of a building for J. C. Penney Company on Steele Street in the 1950s, this vacant lot was used for public meetings and events. Bond rallies during the war and a memorable celebration on VJ Day in 1945 were among the occasions at this location. (From the collection of Jimmy Haire.)

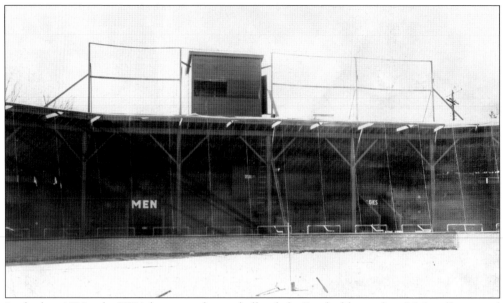

In the late 1930s, the WPA began work on a ballpark for Sanford located on McIver Street and Seventh Street. It was named Temple Park in honor of Will Temple, a local baseball star who played in the New York Giants organization. The Sanford Spinners Class D minor league baseball team played here in 1941, 1942, and 1946–1950. (From the collection of Jimmy Haire.)

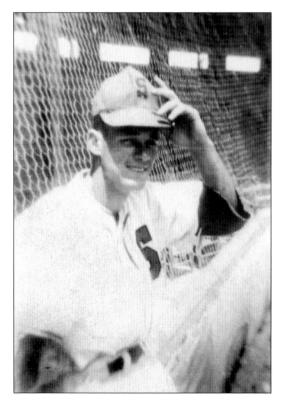

After the end of the war, minor league baseball was wildly popular in the country. Howard Auman returned from war service and pitched for the Spinners in 1946. He won 22 games and lost 8 during his only season with the club. Auman still resides in Sanford. The grandstand was torn down in the 1960s, but the field is still used for playing ball. (Courtesy of Howard Auman.)

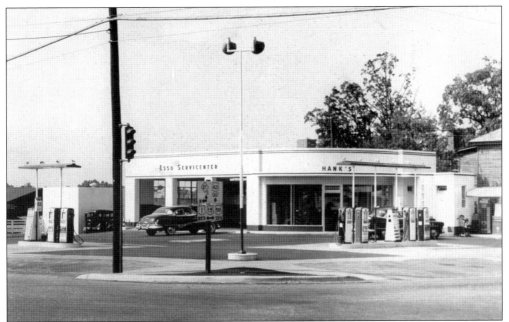

Hank Nesselrode was a slugging star for the Sanford Spinners baseball club during the 1940s. In 1954, he opened a new service station at the corner of Endor and Carthage Streets. It replaced an older station formerly operated by W. J. Womble and K. R. Gallup. The new station would be owned later by M. L. Tucker and Grady Pardue. Grady's Exxon Service would close in 1985. (From the collection of Jimmy Haire.)

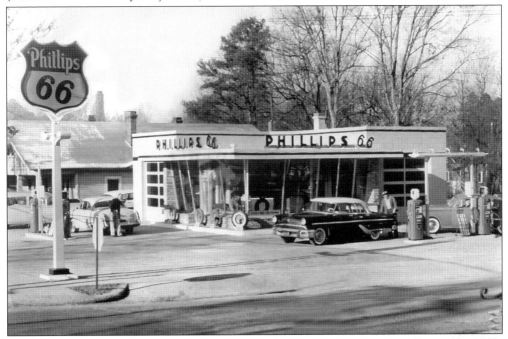

After the war, it became commonplace to see service stations on many corners. During the 1960s and early 1970s, Mitchell West operated a service station at 502 Carthage Street. The site would later become the office of Simpson and Simpson. (From the collection of Jimmy Haire.)

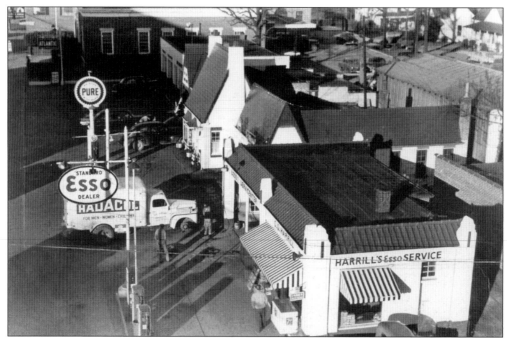

This photograph taken from the top of the Masonic Building at the corner of Carthage and Steele Streets shows that, by the 1940s, the former site of Sanford Graded School was occupied by service stations. In 1968, First Citizens Bank and Trust Company built a new office building at the site of the stations. (From the collection of Jimmy Haire.)

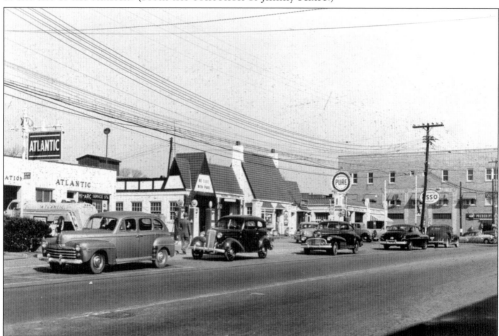

Motorists traveling on Carthage Street pass "Service Station Row." In a small town, it was a challenge to buy gas at one of the three adjoining stations without offending the other station owners. (From the collection of the Railroad House Historical Association.)

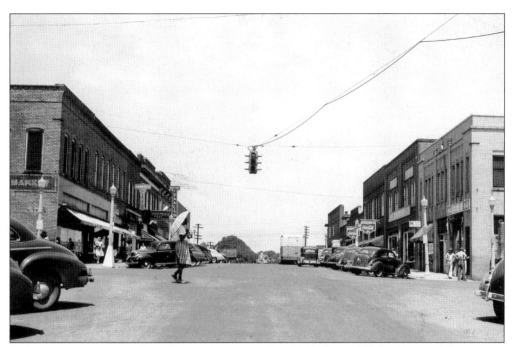

A shopper tries to protect herself from the sun on a hot 1940s day on Wicker Street. A Progressive Super Market is on the left corner. Sam Womble became the manager of the store in 1937. It was the first self-service grocery store in the Progressive chain. (From the collection of Jimmy Haire.)

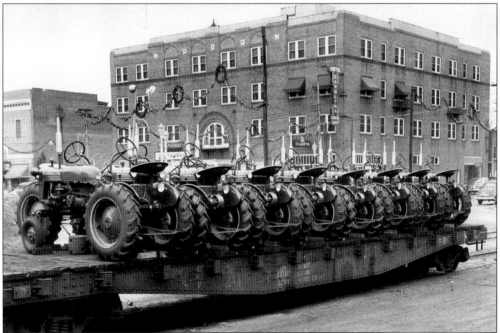

A shipment of tractors sits at the Sanford depot. In the early 1950s, Lee County was the home of approximately 1,655 farms averaging nearly 70 acres per farm. The photograph also offers a view of the beautiful Carolina Hotel and Temple Theatre buildings. (From the collection of Jimmy Haire.)

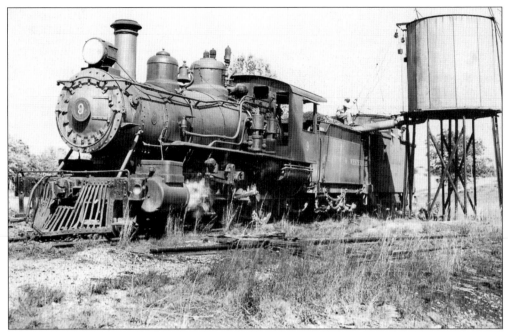

This postcard of the Atlantic and Western Railroad (A&W) Steam Engine No. 9 was prepared in May 1950 for rail enthusiasts. The A&W was chartered by William J. Edwards in 1899, and by 1903, the line had been extended from Sanford to Jonesboro. The railroad still operates today, serving a number of customers through spur lines. (From the collection of W. W. Seymour Jr.)

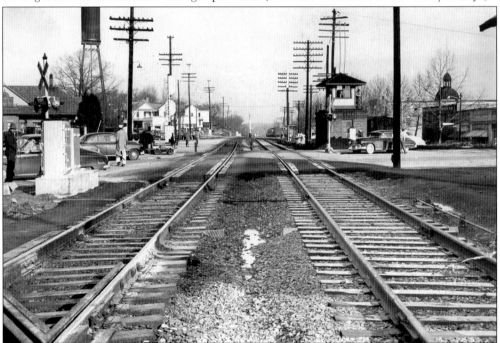

This early 1950s rail vista shows the main Seaboard line through Sanford. The signalman in the small tower activated the warning lights at the crossing when a train was approaching. The crossing now has an automatic signal. (From the collection of Jimmy Haire.)

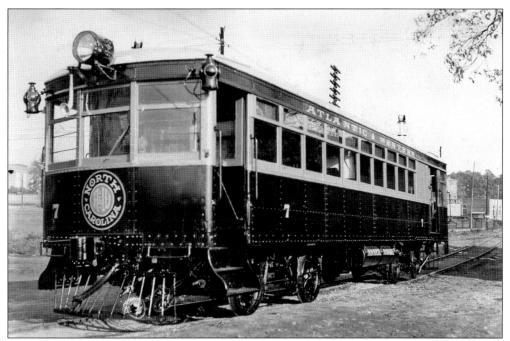

The A&W operated a small passenger rail service from Sanford to Lillington from 1917 to 1948. The train was called the jitney or the "Dinky." The last car used for the service is shown in this photograph. At one time, passengers could travel from Sanford to Lillington for 50¢. (From the collection of Jimmy Haire.)

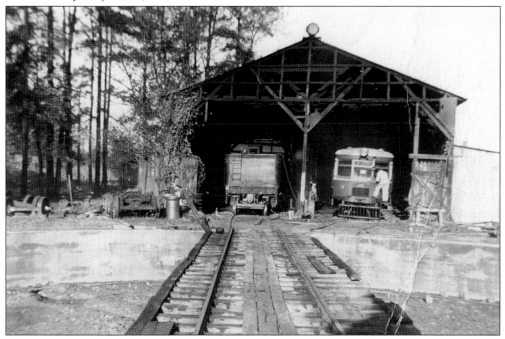

The repair shed for the A&W off Hickory Avenue was an interesting place. Repairs on the jitney cars were made here, and the cars could be turned around on the turntable in the foreground. (From the collection of Jimmy Haire.)

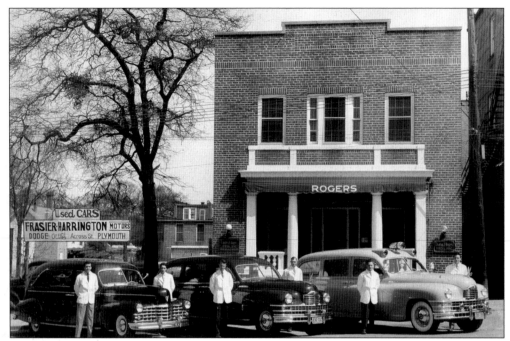

Employees of the Charles P. Rogers Funeral Home on Steele Street show off their fleet of Packard vehicles. From left to right are Stewart Thomas, Charles Cole, Roy Gates, Worth Perry, Tommy Pickard, and Harold York. The funeral home would move to Carthage Street in the 1950s. This building was later a public library. (From the collection of Jimmy Haire.)

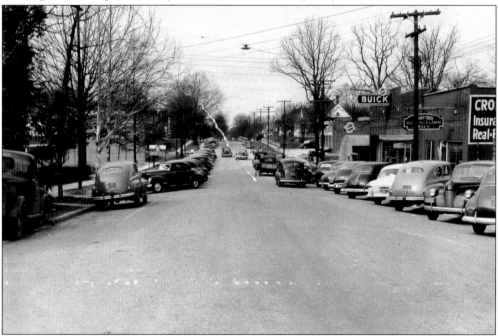

This view of North Steele Street from the early 1950s is taken from near its intersection with St. Clair Court. Garland Perry's Buick dealership is shown. Eventually the Perry Building would be built on the site. (From the collection of Jimmy Haire.)

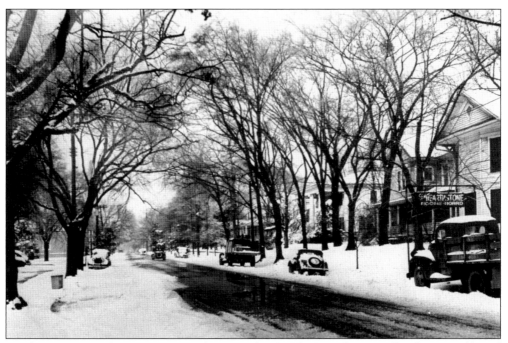

Hawkins Avenue is shown on a snowy day around 1950. The Hearthstone offered room and board to U.S. Highway 1 travelers and local residents. Jones Printing Company now occupies the site of the Hearthstone. (Courtesy of Ralph Monger Jr.)

The Railroad House is the oldest house in Sanford. It occupied the same location on Hawkins Avenue from 1872 to October 11, 1962. The expansion of a neighboring service station threatened the house, and a group of citizens arranged for it to be moved to its present site. (From the collection of Jimmy Haire.)

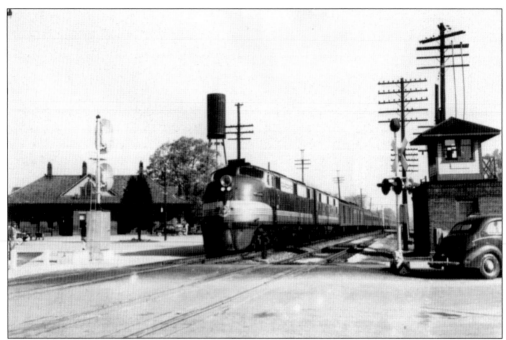

A familiar sight in the 1950s was a Seaboard diesel train engine pulling a load of passengers and/or freight through the middle of Sanford. Passenger service from the Sanford depot continued until April 30, 1971. On May 1, 1971, Amtrak took over all passenger service on the railroads. (From the collection of Jimmy Haire.)

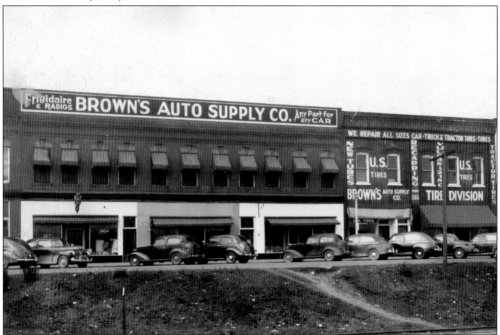

After the war, the sale of used cars increased dramatically, and Brown's Auto Supply Company on Moore Street was there to sell auto parts and supplies. Owner Frank Baber and his staff helped the store's customers find "any part for any car." (From the collection of Jimmy Haire.)

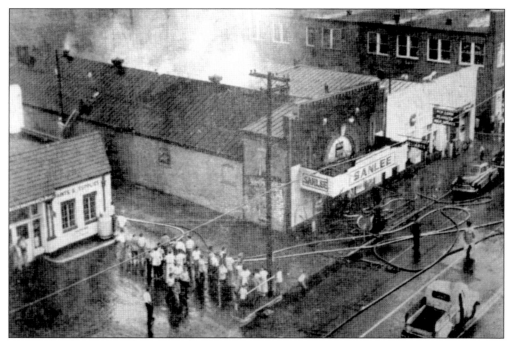

A crowd gathers to watch a fire at the Sanlee Theater on September 19, 1954. The theater would never reopen for business. Less than a month after the fire, the area would be hit by powerful Hurricane Hazel. The location of the theater is now a parking lot across the street from the Temple Theatre. (From the collection of Jimmy Haire.)

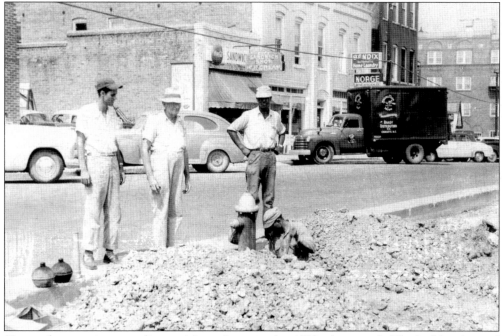

City workers repair a water line on Moore Street in this 1950s photograph. The building located adjacent to the sandwich shop was occupied by Sprott Brothers Furniture Company. It is the present location of Sanford Antique Mall. (From the collection of Jimmy Haire.)

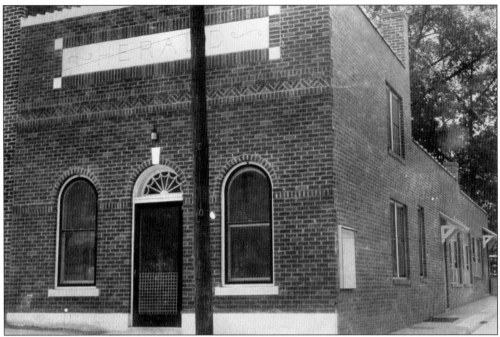

The *Sanford Herald* newspaper constructed this office in 1937, and it served the newspaper until a new office was built nearby in 1952. Attorney W. W. Seymour practiced law in the building from 1952 until the early 1970s. It was demolished in 1973 after the completion of the new First Citizens Bank and Trust Company facility. (From the collection of Jimmy Haire.)

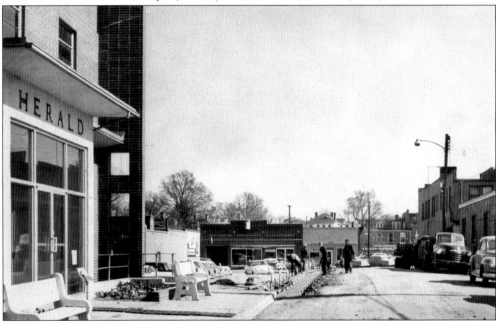

Curb and gutter improvements on St. Clair Court are shown in this 1956 photograph. The *Sanford Herald*'s new office is in the left foreground, while the old newspaper office is shown on the right. The buildings on Steele Street in the distance would soon be demolished for the construction of two financial institutions. (From the collection of Jimmy Haire.)

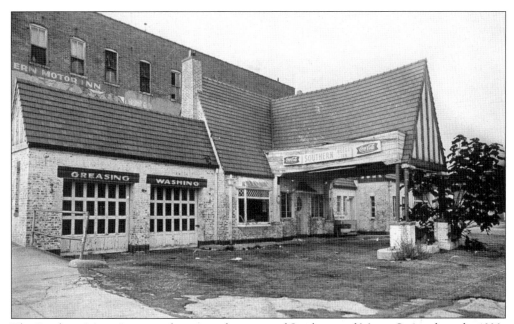

The Southern Motor Inn was a fixture on the corner of Carthage and Moore Streets from the 1930s to the mid-1970s. It is shown here in its later years. Despite the ravages of time, the interesting architecture of the structure is evident. Heritage Park is currently located on this site. (From the collection of Jimmy Haire.)

There was a time when stately homes occupied both sides of Carthage Street. R. P. and Sidney Rosser lived in this home at 346 Carthage Street during the 1940s. Alex B. and Olive P. Wilkins resided here from 1950 to 1964. The home was demolished in 1965 to build a service station. Mid-South Bank and Trust Company built a bank here in the mid-1970s. (From the collection of Jimmy Haire.)

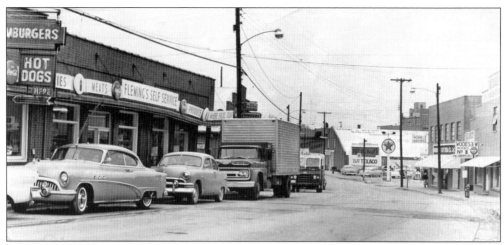

Prior to the mid-1960s, Endor Street was a two-lane thoroughfare extending from Rose Street north to the outskirts of Sanford. A controversial widening of the street to four lanes in the mid-1960s created a boulevard named after *Sanford Herald* publisher and North Carolina highway commissioner William E. Horner. (From the collection of Jimmy Haire.)

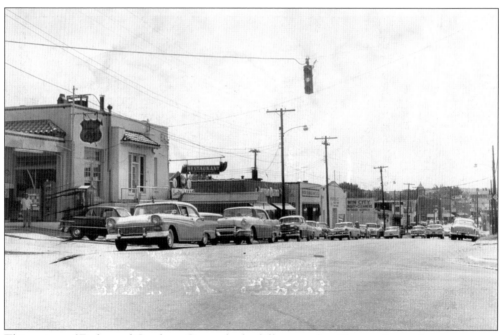

This corner of Endor and Carthage Streets looks different today. The service station, restaurant, and other buildings have been demolished, and the Kenneth Neilsen Studio and Gallery now occupies the site. The four-lane Horner Boulevard provides a steady stream of vehicles daily. (From the collection of Jimmy Haire.)

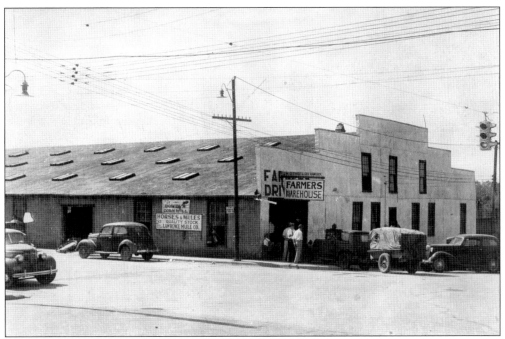

The Farmers Warehouse occupied the corner of Endor and Wicker Streets until a late-1950s fire destroyed it. During the 1960s and 1970s, a Spur gas station occupied the corner. During gas wars in the 1960s, gas sold for as little as 19.9¢ per gallon. (From the collection of Jimmy Haire.)

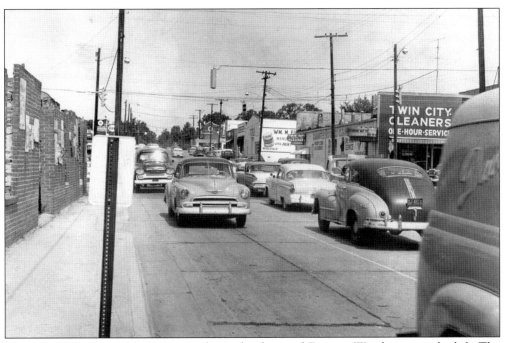

This late-1950s view of Endor Street shows the damaged Farmers Warehouse on the left. The entire block on the right between Wicker and Carthage Streets has changed dramatically in the past 50 years. (From the collection of Jimmy Haire.)

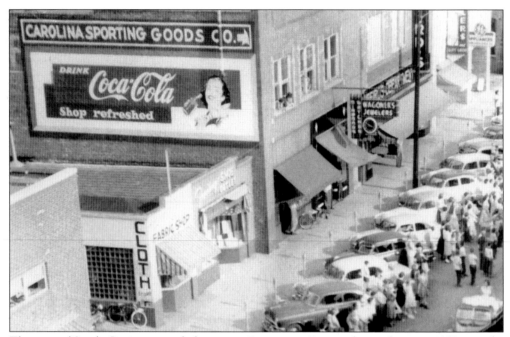

The area of Steele Street currently known as Restaurant Row is shown during a 1950s parade. Carolina Sporting Goods Company was operated by Pat Geer, while Marshall and William Wagoner had taken over their parents' jewelry business. WWGP and WEYE radio stations both operated from the second floor of the building at different times during their early years in the late 1940s and 1950s. (From the collection of Jimmy Haire.)

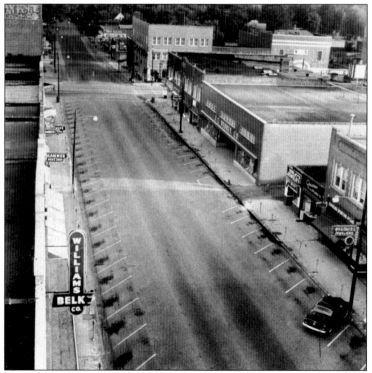

An early-morning view of Steele Street from the Wilrik Hotel in the 1950s shows a placid scene. In a few hours, the downtown section of Sanford would be full of shoppers in the town's main shopping area. (From the collection of Jimmy Haire.)

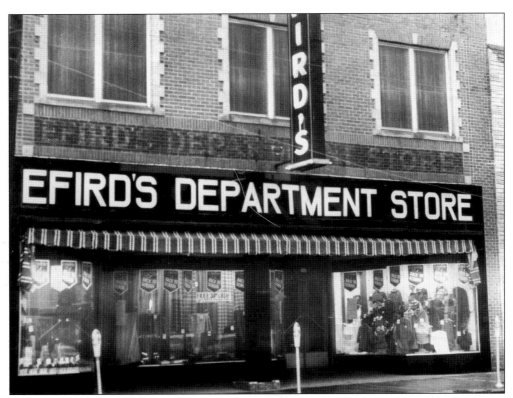

Efird's Department Store is shown during a back-to-school sale. Efird's was a mainstay on Steele Street during the 1930s, 1940s, and 1950s. A unique feature of the store was that when customers purchased items on the second floor, their money and ticket would travel to the sole cashier on the first floor by a basket. (From the collection of Jimmy Haire.)

Railroad tracks require constant maintenance. These rail workers are repairing a spur line through Sanford. The water tower shown was removed from its location on railroad property on June 14, 1954. (From the collection of Jimmy Haire.)

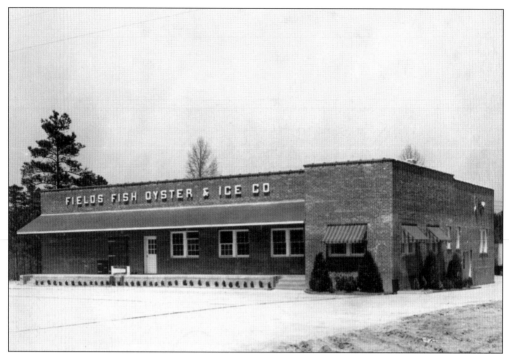

Fields Fish, Oyster, and Ice Company was owned by former Sanford mayor E. W. Fields. The business was a familiar sight on South Horner Boulevard until it closed around 1974. The site is now the location of a Sonic Drive-In. (From the collection of Jimmy Haire.)

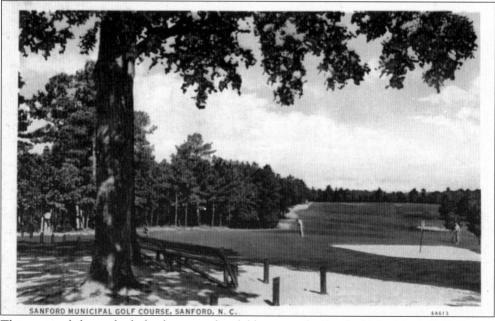

SANFORD MUNICIPAL GOLF COURSE, SANFORD, N. C.

This postcard shows the hole closest to the clubhouse at the Sanford Municipal Golf Course. Construction work began during the New Deal period by the Civil Works Administration and was completed by the Emergency Relief Administration in 1934. The course was designed by Donald Ross, and the clubhouse was completed in 1936. (From the collection of Jimmy Haire.)

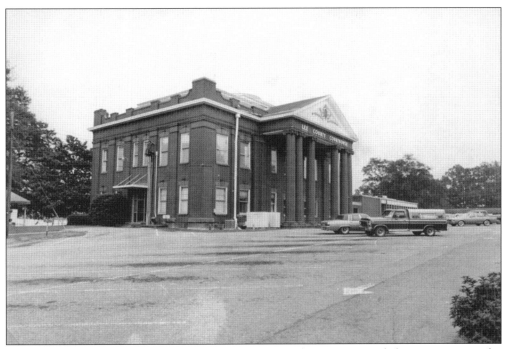

After its construction in 1908, the Lee County Courthouse remained the same size until a small addition in the 1950s. This view of the rear of the courthouse would not change until 1994, when construction of a new courthouse and jail facility was begun. (From the collection of Jimmy Haire.)

The Lee County Home on Nash Street was a familiar sight for a number of decades. It provided a place where the indigent citizens of the county could reside. Prison inmates provided labor for the home, and they resided in the building on the right. The Lee County Civic Center now occupies the site. (From the collection of Jimmy Haire.)

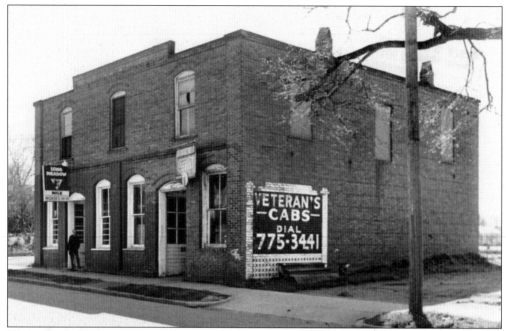

Wicker Cash Grocery is pictured here at its McIver Street location. Gunter Wicker's store provided a place where the students at nearby McIver School could purchase supplies or snacks. Veteran's Cabs was located in the building for many years. (From the collection of the Railroad House Historical Association.)

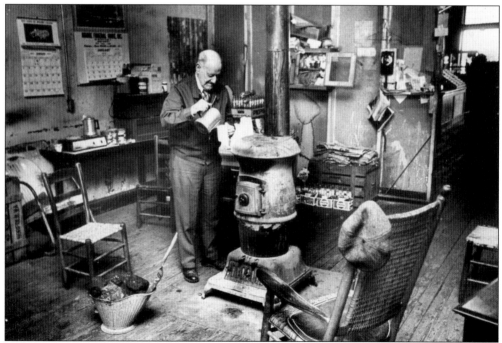

Owen Wicker pours a cup of coffee in the back room of Monger's Seed Store on Wicker Street. Wicker was the first walking mail carrier in downtown Sanford. He began making his rounds in the mid-1920s. This photograph was taken in the mid-1970s. (From the collection of Jimmy Haire.)

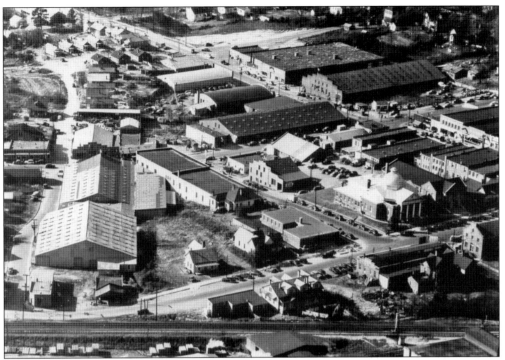

This aerial photograph from the early 1950s shows the warehouse district of downtown Sanford. Warehouses were abundant on Endor and Wicker Streets during this period. The dome of Steele Street Methodist Church is a familiar landmark. (From the collection of the Railroad House Historical Association.)

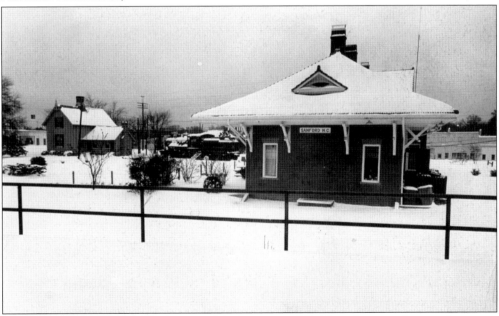

The depot area of Sanford looks peaceful after a snowfall. This photograph was taken years ago, long before the concept of Depot Park would begin to take shape. (From the collection of Jimmy Haire.)

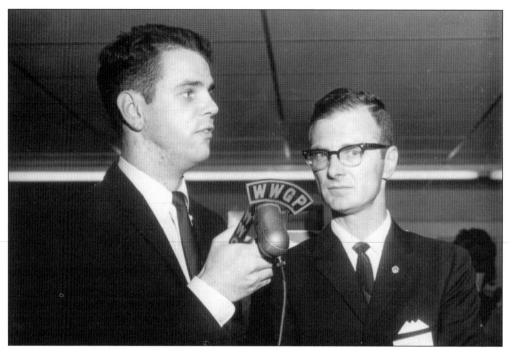

Jimmy Bridges Jr. (right), an employee of Lee Cabinet and Store Fixture Company, is interviewed by a WWGP radio announcer. The occasion was the opening of Lee Cabinet's new facility on Highway 421 North in October 1963. The business is now called Lee Builder Mart. WWGP is Sanford's oldest radio station. It began broadcasting in 1946 at 1050 on the AM band. (Courtesy of Lee Builder Mart.)

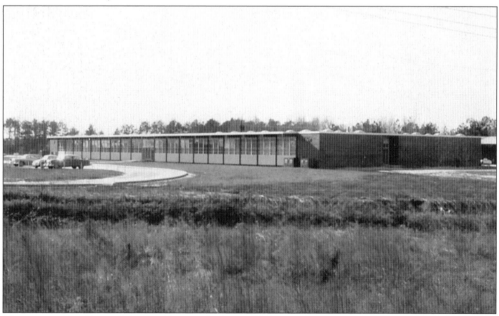

The original building of the Lee County Industrial Education Center was completed in September 1962 on a 25-acre Kelly Drive site. The institution has grown over the past 40 years. It is now called Central Carolina Community College. (Courtesy of Central Carolina Community College.)

Four

JONESBORO

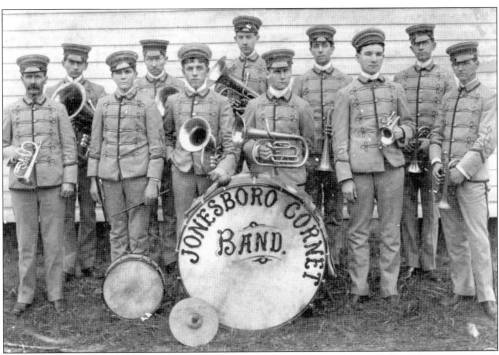

The Jonesboro Cornet Band poses at the Jonesboro Bank around 1905. From left to right are (first row) D. B. Buchanan, Hasty Campbell, Elmer Buchanan, John M. Lloyd, and Will Sloan; (second row) Bob Nelson, Lacy Wicker, Grover Cox, M. C. Thomas, W. L. Thomas, and O. C. Liles. (From the collection of the Railroad House Historical Association.)

In 1860, a town was laid out at a high place on the Western Railroad in Moore County. It was named Jonesboro after Col. Leonidas Campbell Jones, builder of the early railroad constructed in the area. The town was incorporated in 1872, two years before Sanford received its charter. (Courtesy of James Vann Comer.)

West Main Street was a dirt road at the turn of the century. Residents of Jonesboro began their long trip to the county seat of Carthage by traveling down this road. It was a journey that could take the entire day using a horse and buggy. (From the collection of Jimmy Haire.)

76

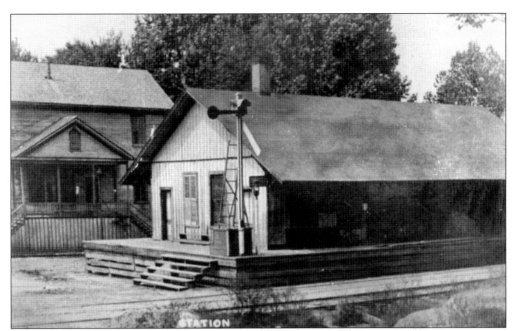

The Jonesboro railroad depot was located at Fayetteville and Raleigh Streets. The site selected for the Lee County Courthouse was halfway between this depot and the one in Sanford. The town hall is shown in the background in this early-20th-century photograph. (From the collection of Jimmy Haire.)

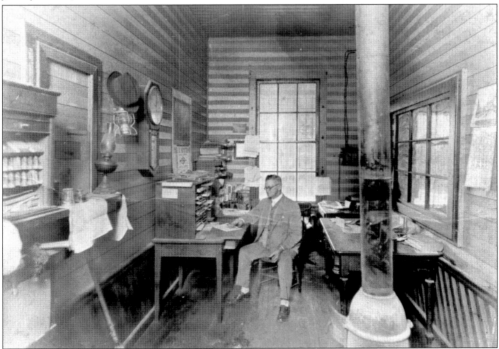

This photograph from the 1920s shows C. H. Russell in the Jonesboro depot. The Western Railroad in its early years extended from Fayetteville to Egypt. The railroad line would eventually extend to Wilmington. (From the collection of the Railroad House Historical Association.)

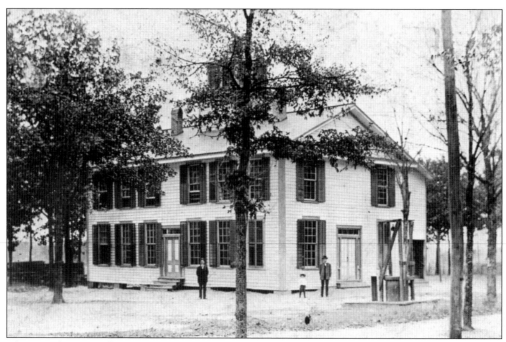

The Jonesboro Academy was founded in the 1870s. It was affiliated with the Jonesboro Methodist Church and was located on the western outskirts of town. (From the collection of the Railroad House Historical Association.)

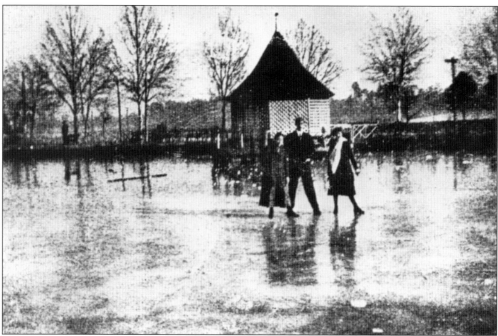

Jonesboro citizens ice-skate on a frozen pond around 1900. The pond was located next to the Tinney Inn, a sprawling hotel on Lee Avenue. The area where the hotel and pond were formerly located is still vacant between houses located at 2020 and 2114 Lee Avenue. (From the collection of the Railroad House Historical Association.)

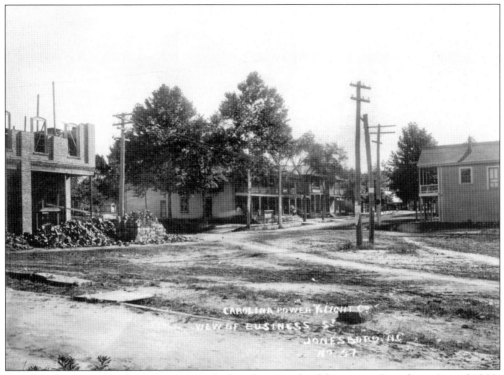

Carolina Power and Light Company made this photograph of downtown Jonesboro around 1900. It shows the J. Alton McIver Building under construction. A fire on July 16, 1911, would destroy the frame buildings pictured here, but the McIver Building would survive. (From the collection of Jimmy Haire.)

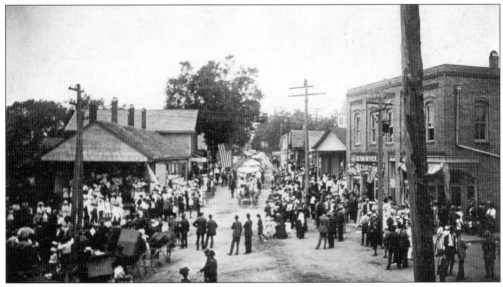

A parade on Trade Street was held on July 4, 1909. Trade was the main street in downtown Jonesboro at this time. The J. Alton McIver Building is prominent on the right side of the photograph. The building is still being used in the 21st century. (From the collection of the Railroad House Historical Association.)

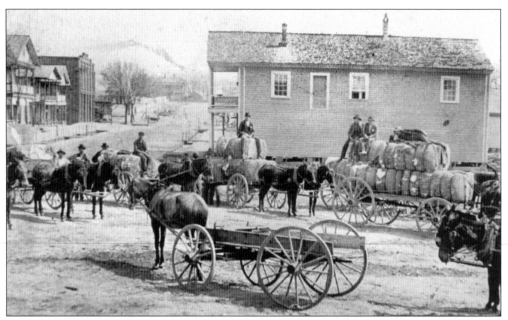

These wagons on Trade Street around 1900 were on their way to Hasty Campbell's cotton gin. As the turpentine industry diminished in the area, more farmers turned to cotton as a source of income. (From the collection of Jimmy Haire.)

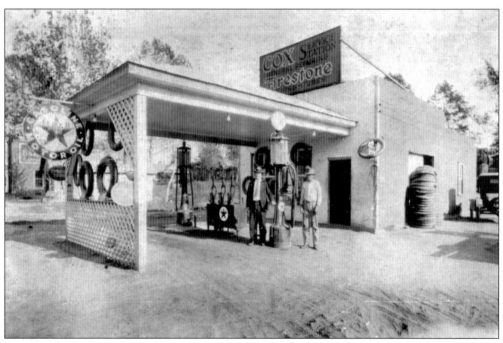

The Cox Service Station on Trade Street opens for business on March 7, 1929. The station was operated by Seth T. Cox. His son, Seth T. Cox Jr., is president of John Wm Brown Company, a general contractor that utilizes Cox Sr.'s second service station site on Main Street as an office. (From the collection of Jimmy Haire.)

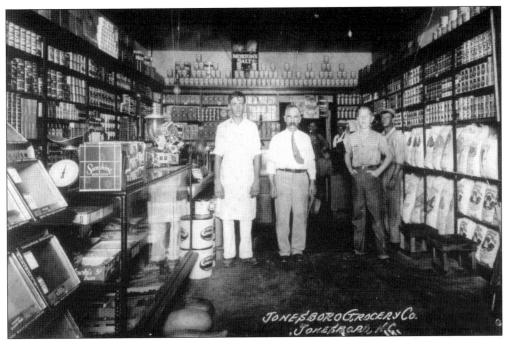

This 1930 view of Jonesboro Grocery Company shows proprietor W. F. Lloyd (wearing the tie) standing with one of his sons and some customers. After his death, Mr. Lloyd's sons Jack and Joe continued to operate the grocery store, while son Will operated a nearby hardware store. (From the collection of Jimmy Haire.)

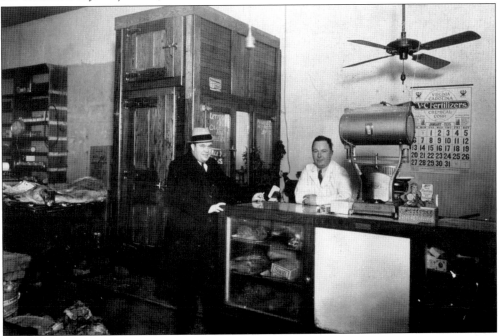

This view inside O'Connell's Grocery in 1935 shows Albert White visiting with Floyd O'Connell. O'Connell's continues in operation today on Main Street under the ownership of Mike Stone. (From the collection of Jimmy Haire.)

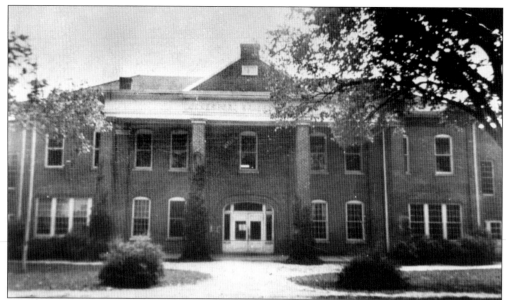

Jonesboro Graded School was completed in 1911. It replaced the frame school that had served the community for a score of years. This view of the school is from 1935. Jonesboro School would serve the community as an all-grade institution until the high-school students moved to the new Sanford Central High School in 1952. (From the collection of the Railroad House Historical Association.)

This view of Jonesboro Elementary School shows the changes made to the building in its later years. The school would close in 1977, and the building would be demolished in 1981. (From the collection of Jimmy Haire.)

Until the 1960s, Lee Avenue extended from the present Chatham Street and Short Street intersection to Main Street in Jonesboro. This view shows the Abe Kelly house and historical marker on Main Street that marked the end of Lee Avenue. The house would be demolished in the 1960s, and Lee Avenue Extension would be constructed. (From the collection of Jimmy Haire.)

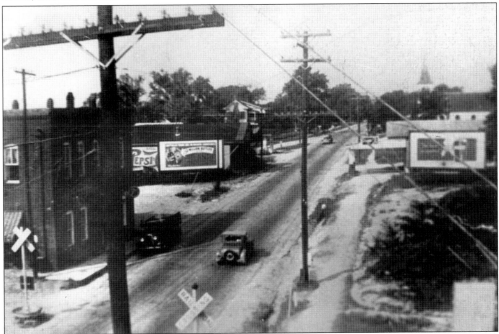

This view of Main Street looking west is from around 1930. The Abe Kelly house and the steeple of Jonesboro Presbyterian Church can be seen. A number of the Main Street buildings downtown had not yet been constructed. (From the collection of Jimmy Haire.)

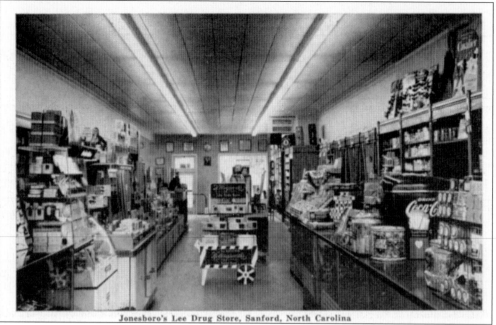

Jonesboro's Lee Drug Store, Sanford, North Carolina

Jonesboro's Lee Drug Store opened on Main Street in the 1920s. This postcard is from the early 1940s, when the store was under the ownership of Fred Ray Jr. and Robert Neal Watson. Marcus Cameron was later an owner of the store. It closed in the 1990s. (From the collection of Jimmy Haire.)

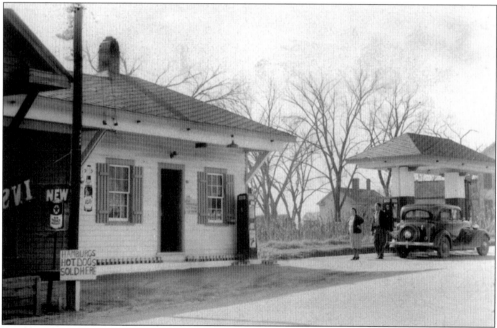

The point at the intersection of Main and Trade Streets has been a center of activity in Jonesboro for almost a century. This 1930s photograph shows a gas station and store. The Milky Way Restaurant would operate here later. The site is currently occupied by the Landmark Restaurant. (From the collection of Jimmy Haire.)

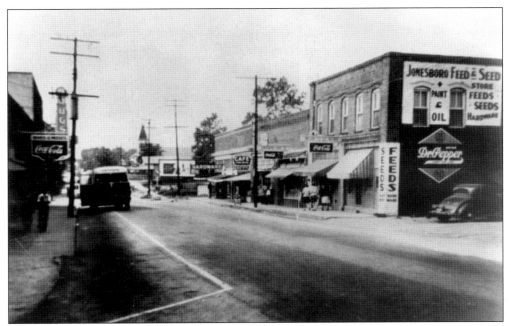

This photograph of Main Street looking west is from the 1940s. Businesses shown include Jonesboro Lee Drug Store, Jonesboro Feed and Seed, and Lloyd's Hardware. (From the collection of Jimmy Haire.)

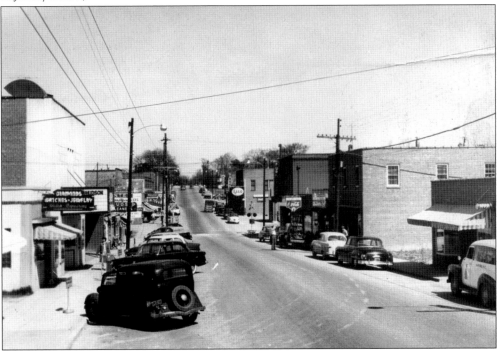

This scene shows Main Street looking east. By the 1950s, the Center Theater had been constructed. The Esso sign indicates the second location of the Cox Service Station. The department store Avent and Thomas has been in business in a building beyond the service station since 1928. (From the collection of Jimmy Haire.)

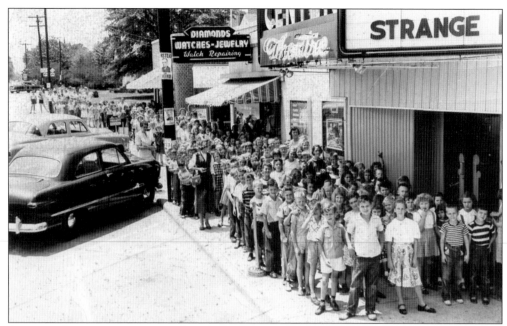

A group of youngsters waits in a long line to see a movie at the Center Theater in 1952. The theater sponsored a number of events over the years. A showing of a Beatles movie in 1964 resulted in long lines for several days. (From the collection of Jimmy Haire.)

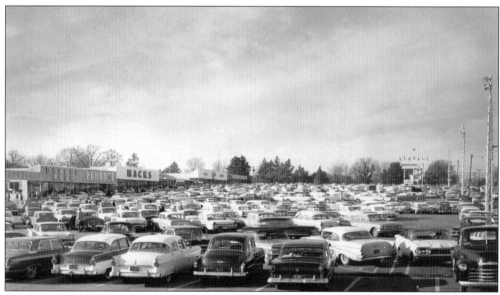

Kendale Shopping Center opened on Lee Avenue Extension in 1962. The large strip shopping center was a first for Lee County, and it was an immediate success. A&P, Mack's, Mann's Drug, and Better Life Store were early tenants. (From the collection of Jimmy Haire.)

Five

PLACES OF WORSHIP

St. James African Methodist Episcopal Church constructed this building at 809 Boykin Avenue in 1921. It was demolished in 1976, and the congregation moved to a different building at 1024 Boykin Avenue. (From the collection of Jimmy Haire.)

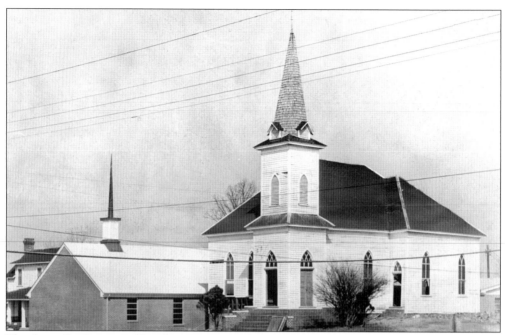

Blandonia Presbyterian Church was organized in 1867. The first church was on the corner of Steele and Wicker Streets. The frame church pictured here was built at the corner of Wall and Endor Streets in 1906. This 1964 photograph shows the soon-to-be-demolished church beside the current brick church. (From the collection of Jimmy Haire.)

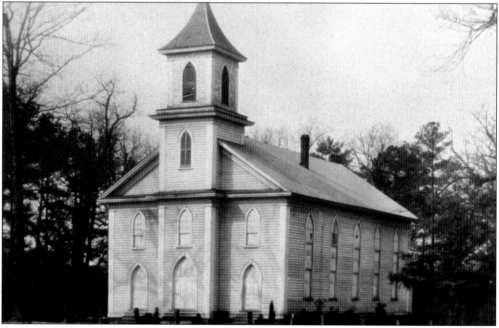

Buffalo Presbyterian Church was established in 1797. The current frame church was built in 1879 and is the fourth building at the same site. The Buffalo congregation has been responsible for the organization of several Presbyterian churches in the area. The adjoining cemetery is the largest in the county. (From the collection of Jimmy Haire.)

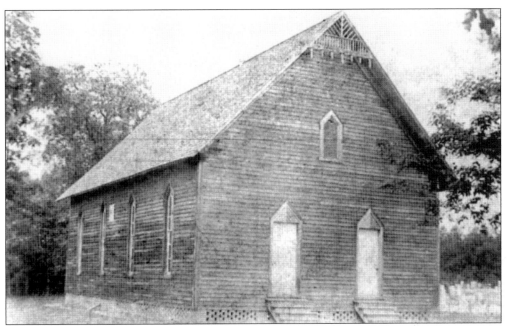

Center United Methodist Church started in 1818 as Center Union. In 1885, the church erected the structure shown here. The building was remodeled in 1912, and in 1950, the present church building was constructed. The church is located at 4141 South Plank Road. (Courtesy of Mack Wicker.)

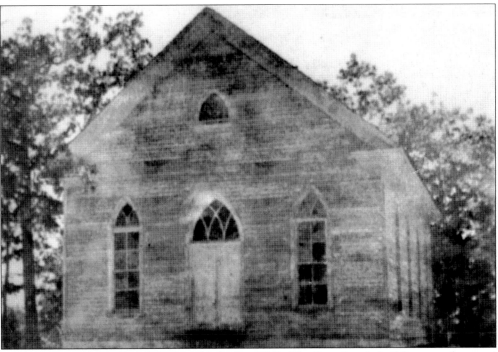

Cool Springs Baptist Church was established in 1848. The first church building was destroyed by a cyclone on April 5, 1905. The only items that escaped destruction were the Bible, the pulpit altar, two straight chairs, and some benches. This photograph shows the structure completed by the end of 1905. (Courtesy of Cool Springs Baptist Church.)

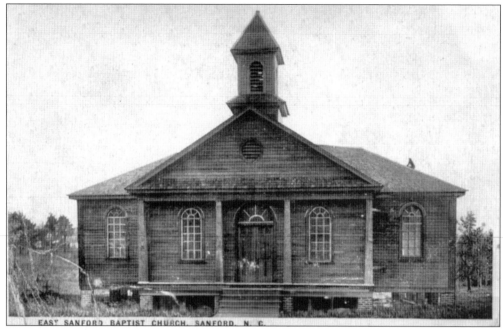

Happy Hollow Sunday school began meeting in a dwelling house in 1913. By September 1919, the East Sanford Baptist Church had been organized. The building shown here was constructed in 1922. It has been enlarged and remodeled over the years. The church is located at 300 North Avenue. (From the collection of Jimmy Haire.)

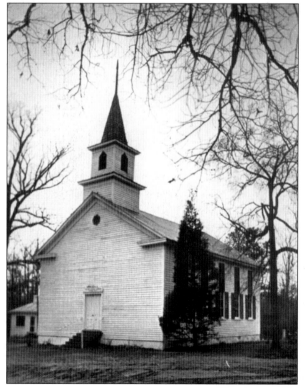

Euphronia is derived from a Greek word for "harmony of mind and body." The Euphronia Presbyterian Church congregation developed from the c. 1811 Euphronian Academy. The present building was built 1885–1886. It is located at 3800 Steel Bridge Road in the Carbonton area. (From the collection of Jimmy Haire.)

Fair Promise AME Zion Church is one of the oldest churches in Lee County. It was organized in 1868. The present church building on Wall Street is the third for the congregation. It was built by well-known contractor and church member A. Lincoln Boykin in 1924. (From the collection of the Railroad House Historical Association.)

First Baptist Church was organized in 1893. The congregation met at the Sanford Graded School at the corner of Carthage and Steele Streets until the nearby church building pictured below was completed in 1896. The church sold its property and built the current church building on Summitt Drive in 1924–1925. (From the collection of Jimmy Haire.)

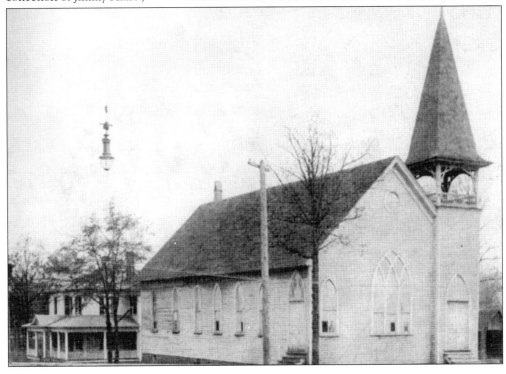

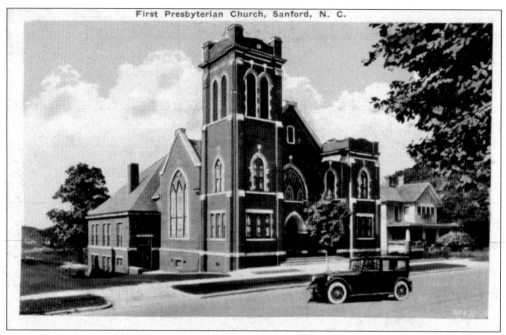

First Presbyterian Church was organized in 1894. Early Sanford leader Maj. John W. Scott was a charter member. The original frame church was replaced by the brick building shown here in 1913–1914. It was severely damaged by fire in December 1927. The church was rebuilt and is located today at the same Hawkins Avenue site. (From the collection of W. W. Seymour Jr.)

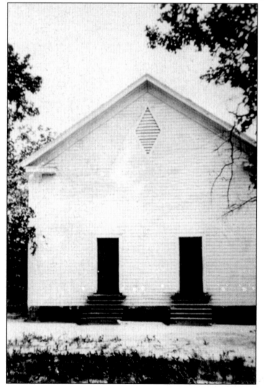

Grace Chapel Church was organized in 1884 in the Tramway area. It was named Grace's Chapel by the first pastor, Rev. D. F. Jones, in honor of his daughter. The church building pictured here was completed in 1886, and it was used until the early 1930s. The church is located at the same site today on U.S. 1 South. (Courtesy of Sherri Reynolds.)

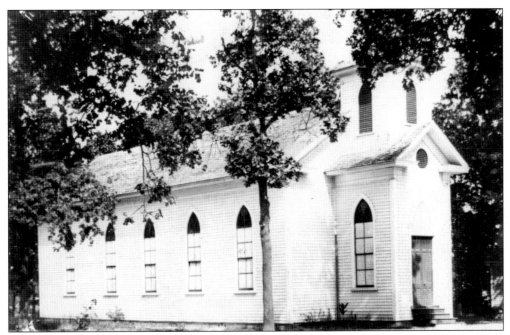

Jonesboro Heights Baptist Church was organized in 1869 and has been located at the same West Main Street site since. The second, 1889–1951 building is shown. New sanctuaries were built in 1951 and 1975. All 48 church members who served in the military through World War II returned unharmed. (From the collection of the Railroad House Historical Association.)

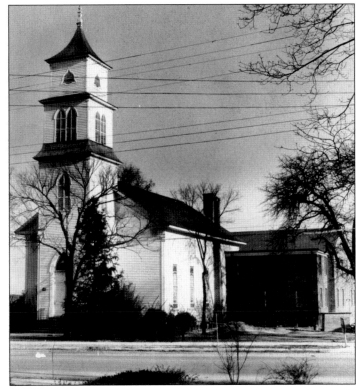

Jonesboro United Methodist Church was organized in 1875, and the frame building pictured was started in 1877. It was replaced by the current sanctuary in 1965. The West Main Street church was responsible for the success of the Jonesboro Academy in the 1870s. (From the collection of Jimmy Haire.)

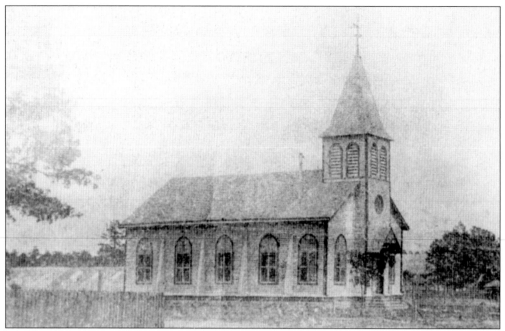

Jonesboro Presbyterian Church was organized in 1885. This church building, located at the corner of West Main Street and Lee Avenue, was used until 1992. The congregation located to a new church facility at 2200 Woodland Avenue on May 31 of that year. (From the collection of Jimmy Haire.)

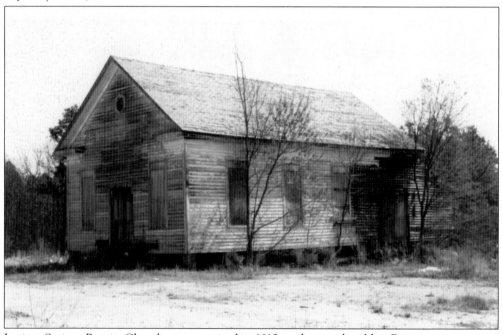

Juniper Springs Baptist Church was organized in 1812, making it the oldest Baptist congregation in Lee County. The church shown here was built on Buckhorn Road near Broadway in 1885. The present church building was built in front of the 1885 one pictured here. (From the collection of the Railroad House Historical Association.)

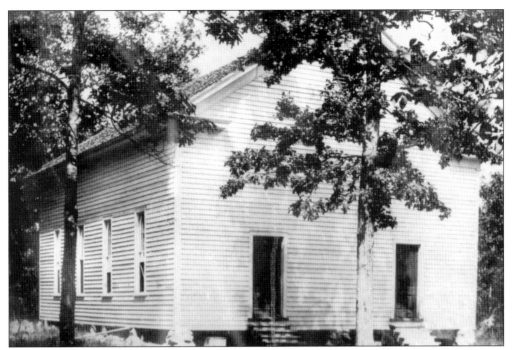

Lemon Springs United Methodist Church organized and constructed this church building in 1890. The doors of the church faced Greenwood School. Female members of the church used one door, while male members used the other. The current sanctuary was built in 1924 at the same location. (Courtesy of Lemon Springs United Methodist Church.)

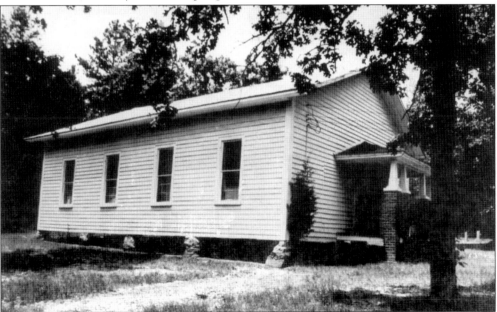

Memphis Methodist Church had its origin as early as 1797 and was the oldest Methodist congregation in Lee County. The church building pictured here was built in 1876 on Poplar Springs Church Road. Although the congregation does not meet on a regular basis today, the church is still used for reunions. (From the collection of Jimmy Haire.)

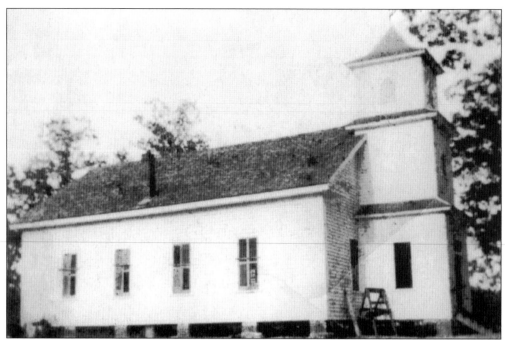

Poplar Springs United Methodist Church was founded in 1836 as a result of brush arbor revivals. The church pictured here was built in 1868. When it was originally built, it faced north and south, but in 1925, it was turned to face east and west. This photograph is from 1925, after it had been moved. (Courtesy of Margery Cole.)

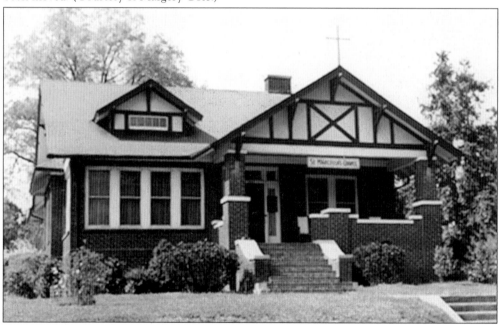

The St. Stephen Catholic Church parish first organized in 1896. Pictured here is St. Marcella's Chapel at 410 Summitt Drive, which was used by the church from about 1930 until the new St. Stephen church on Wicker Street was completed in 1960. A new church on Franklin Drive was completed in 2005. (From the collection of Jimmy Haire.)

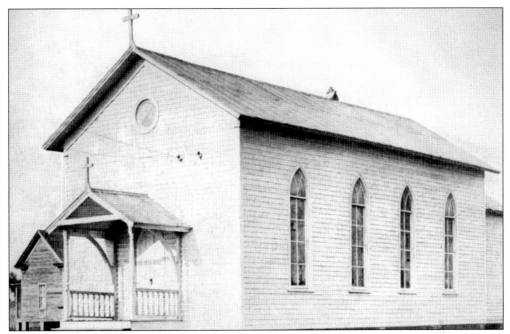

St. Thomas Episcopal Church was organized in 1893. The congregation first met at a Carthage and Moore Streets location, but it moved to the First Street site pictured here in 1910. The current brick church at 312 North Steele Street was constructed in 1930. (From the collection of Jimmy Haire.)

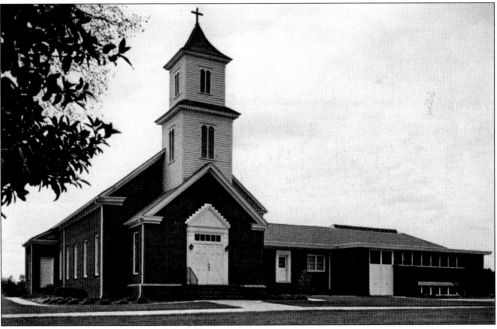

Shallow Well United Church of Christ was organized in 1831. Services were first conducted under a brush arbor, and a well dug at the site struck water four feet below the surface. The core of the present church was constructed in 1877. This postcard from the 1960s shows the changes to the church that continue even to the present. (From the collection of W. W. Seymour Jr.)

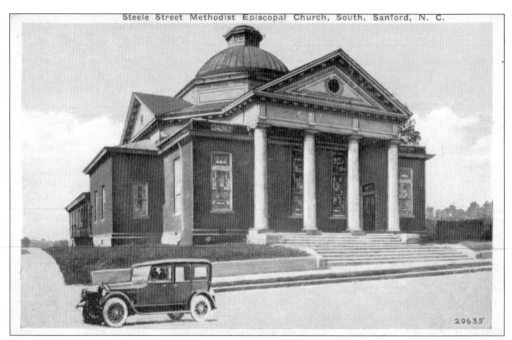

Steele Street Methodist Church was organized in 1887. The church depicted here was built in 1915 and was located at the corner of Steele and Cole Streets. In the early 1970s, the members voted to relocate to a Wicker Street site. When the congregation moved into the new facility in 1974, it became St. Luke United Methodist Church. (From the collection of Jimmy Haire.)

A Baptist congregation began to worship in a brush arbor in 1880. It moved to sites on Steele Street and Pearl Streets before becoming the Wall Street Baptist Church in 1922. The Wall Street building pictured here was used until the present First Calvary Baptist Church facility on Fields Drive was completed in 1973. (Courtesy of First Calvary Baptist Church.)

Six

FOOD AND LODGING

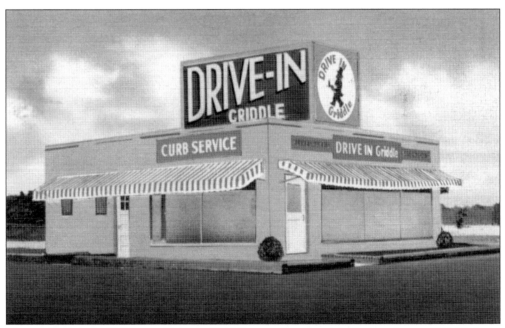

Monroe S. Campbell's Famous Drive-in Griddle was a familiar sight for travelers on U.S. Highway 1-15-501 north of Sanford after 1945. Over the years, the building has changed in appearance, but it is still located on Hawkins Avenue across from the Wyeth entrance. (Courtesy of Betty C. Hurley.)

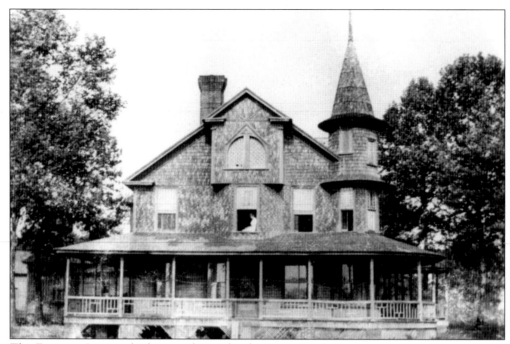

The Egyptian Inn was built around 1890 by the Egypt Coal Company as part of a grand plan to develop the area around the mine into a thriving town. Mining disasters took their toll on Egypt, and this grand hotel was eventually demolished. (From the Hal Tysinger collection of the Railroad House Historical Association.)

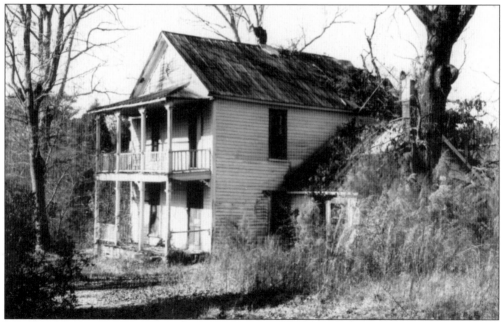

John W. Scott and Kate S. Scott built this house around 1880 at the Lemon Springs resort. Persons would travel to the natural mineral spring and stay for a few days. The house was still standing in this 1994 photograph. The site of the spring is just off U.S. Highway 15-501 traveling toward Carthage. (From the collection of the Railroad House Historical Association.)

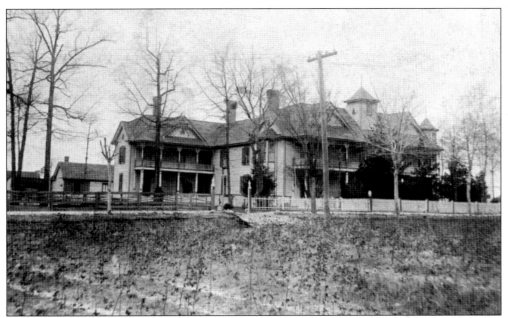

The Tinney Inn was a sprawling hotel built on Lee Avenue about 1890. This front view shows the size of the structure. It became known as the Birches in 1907, when the Birch family moved in. The building burned in 1913. (From the collection of the Railroad House Historical Association.)

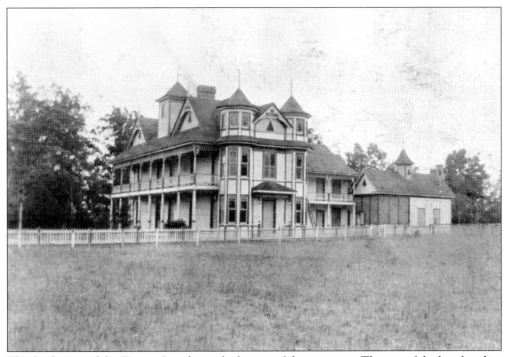

This back view of the Tinney Inn shows the beauty of the structure. The site of the hotel and its adjacent pond is a vacant area between houses located at 2020 and 2114 Lee Avenue. (From the collection of the Railroad House Historical Association.)

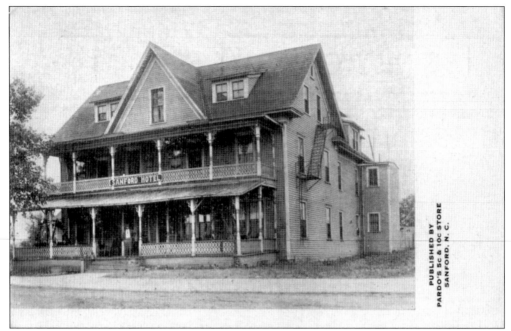

The first Sanford Hotel was built in 1887 by J. M. Monger. It was located next to the railroad tracks on South Moore Street, just south of Wicker Street. The wooden structure burned in 1891. (From the collection of Jimmy Haire.)

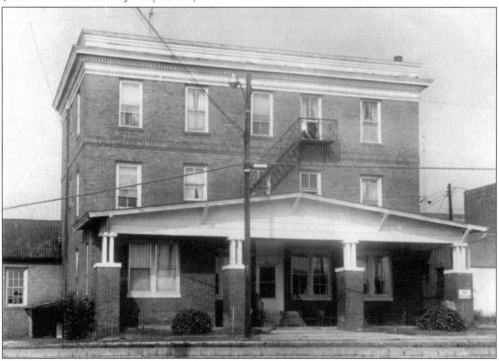

The second Sanford Hotel was a brick structure constructed in the 1920s. It was located at the same South Moore Street location as the first hotel. Railroad workers stayed at the hotel during its 50 years of existence. (From the collection of Jimmy Haire.)

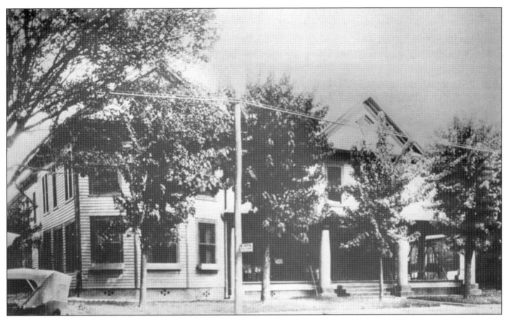

W. A. Maness and Sarah Kelly Maness bought a 12-room house on Hawkins Avenue in 1910. By the time it was demolished in the 1970s, it had been remodeled four times and contained 36 rooms. The Hearthstone was used for lodging and boarding during its long history. Well-known Sanford resident Ruth B. Gurtis grew up in the inn operated by her mother, Mary Maness Bain. (From the collection of Jimmy Haire.)

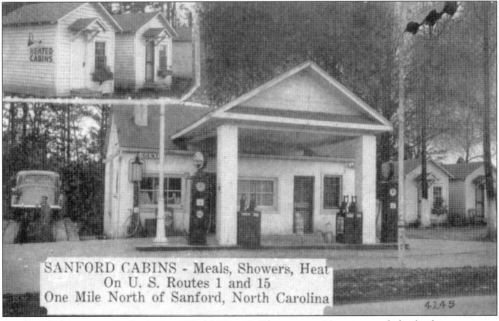

SANFORD CABINS - Meals, Showers, Heat
On U. S. Routes 1 and 15
One Mile North of Sanford, North Carolina

Sanford Cabins were built during World War II. There were 10 units, and the bathrooms were in the rear of the Hawkins Avenue service station in front. The cabins were steam-heated from a central unit. Garland Perry owned this business at one time. The name was later changed to Sanford Tourist Court. (From the collection of Jimmy Haire.)

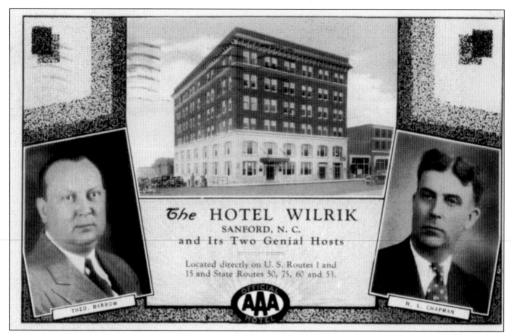

The Wilkins-Ricks Company opened its new Wilrik Hotel in August 1925. The first event at the new hotel was a luncheon meeting of the Sanford Rotary Club. A number of different postcards of the hotel have been published in the years since the opening. (From the collection of W. W. Seymour Jr.)

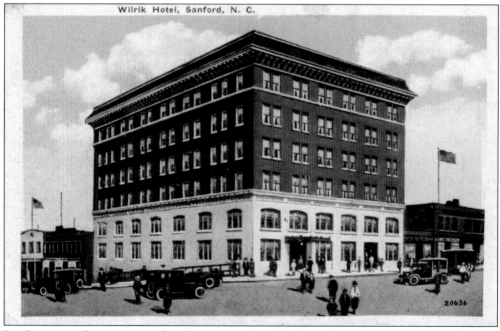

Joe Stout was the contractor for the six-story hotel. Indiana limestone was used on the two bottom floors, while the top four floors were constructed with brick. The Wilrik has dominated the skyline of Sanford for over 80 years. (From the collection of W. W. Seymour Jr.)

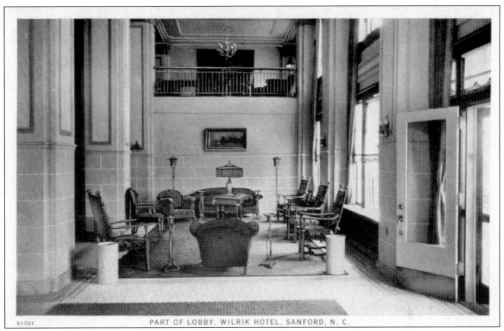

The lobby of the Wilrik Hotel is shown in this 1930s postcard. The hotel served as the Lee County Government Center during the 1970s and early 1980s. It has been remodeled and used for housing in recent years. (From the collection of W. W. Seymour Jr.)

After the Wilrik Hotel had been completed, O. P. Makepeace and Frank Snipes announced plans to build a hotel on the corner of Carthage and Moore Streets. The Carolina Hotel was built in 1926–1927 and opened in 1929. This late-1940s view of the hotel shows its magnificent construction. It is now used for housing. (From the collection of Jimmy Haire.)

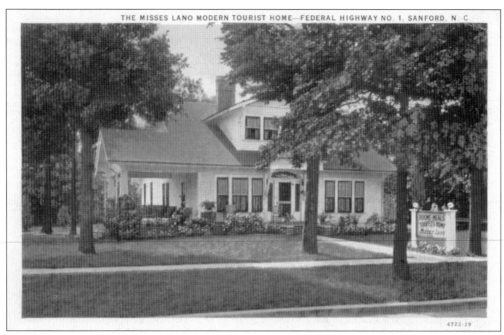

THE MISSES LANO MODERN TOURIST HOME—FEDERAL HIGHWAY NO. 1, SANFORD, N. C.

Lano Tourist Home was located at 507 Carthage Street. Mr. and Mrs. C. A. Lano opened their house as a tourist home in 1936. It later became the Misses Lano Tourist Home. The site was near the present Rogers-Pickard Funeral Home location. (From the collection of Jimmy Haire.)

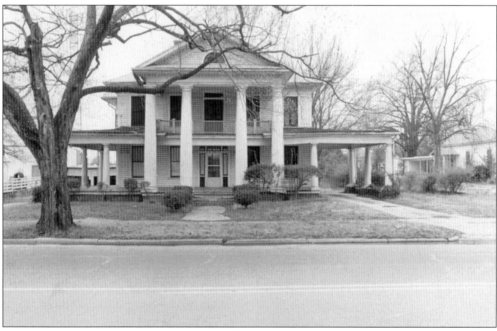

Bessie Oliver operated a boarding house in the former residence of Dr. W. A. Monroe on Hawkins Avenue for a number of years. Her meals were enjoyed by countless residents and visitors. The house was demolished to build the Suzanne Reeves Library. (From the collection of Jimmy Haire.)

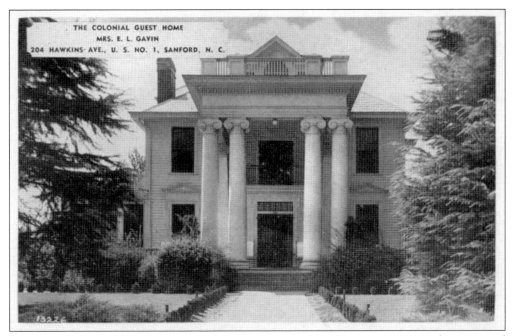

Edwin L. Gavin and Mary Gavin built this house on Hawkins Avenue in 1922. In the 1930s and 1940s, it was used as a guest home, and these postcards were prepared for the guests to use. (From the collection of W. W. Seymour Jr.)

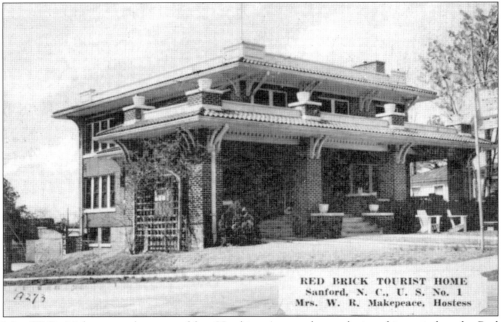

Mrs. W. R. Makepeace also opened her Hawkins Avenue home during this period as the Red Brick Tourist Home. It was located at the corner of Hawkins Avenue and Chisholm Street. (From the collection of Jimmy Haire.)

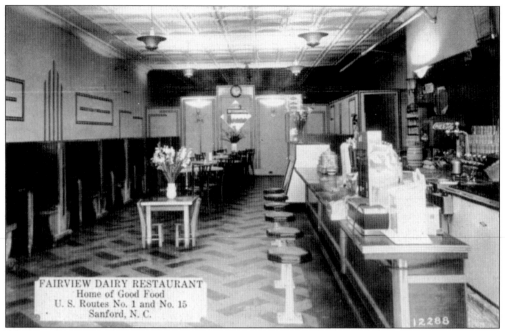

FAIRVIEW DAIRY RESTAURANT
Home of Good Food
U. S. Routes No. 1 and No. 15
Sanford, N. C.

Phil C. Yarborough opened the Fairview Dairy Restaurant in the mid-1930s. Located at 126 Carthage Street, it was an outgrowth of Fairview Dairies. Lawrence F. Cheatham operated the restaurant in the 1950s and 1960s as Larry's Fine Food. (From the collection of W. W. Seymour Jr.)

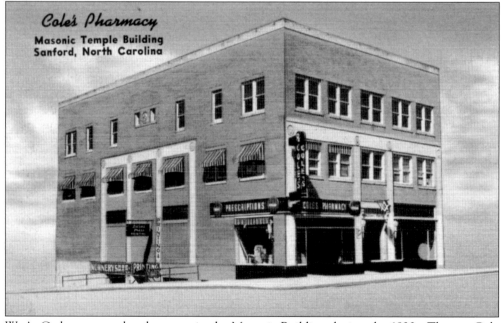

Cole's Pharmacy
Masonic Temple Building
Sanford, North Carolina

W. A. Crabtree started a pharmacy in the Masonic Building during the 1930s. Thomas Cole worked with Crabtree and purchased the business in the 1940s. Later John Terrell operated the pharmacy until he relocated it to Vance Street in 1960. Everett and Virginia Brooks operated the Bootery there from 1960 to 1997. (From the collection of Jimmy Haire.)

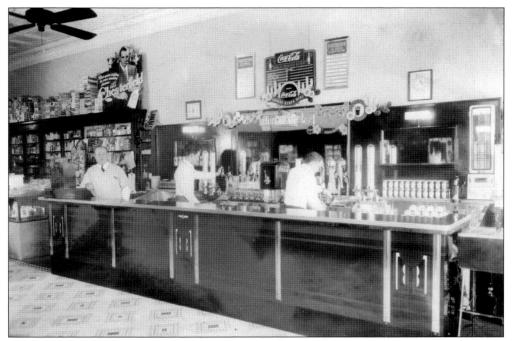

Lee Drug Store was located at 101 South Steele Street from the late 1920s until the early 1980s. Joe Lazarus operated the store for most of those years, and he is shown here behind the popular soda fountain. Lazarus died in 1974. (From the collection of the Railroad House Historical Association.)

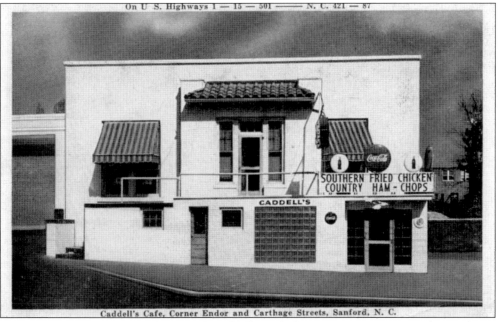

Mr. and Mrs. Hasty Campbell operated Caddell's Café from 1948 to 1954. It was later Oliver's Café and, from 1965 to 1968, the first location of Mrs. Wenger's Restaurant. A service station was constructed on the site in 1969–1970. It is now the location of Kenneth Nielsen's Gallery. (From the collection of W. W. Seymour Jr.)

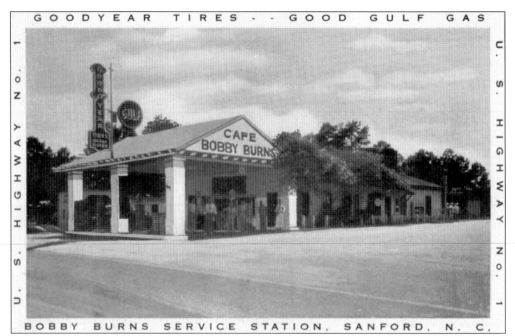

BOBBY BURNS SERVICE STATION, SANFORD, N. C.

Bobby Burns operated a service station at the intersection of Carthage Street and Carbonton Road. He also owned the nearby Three Points Café. Burns built tourist cabins next to the service station in the mid-1930s and operated Bobby Burns Oil Company from this location. (From the collection of Jimmy Haire.)

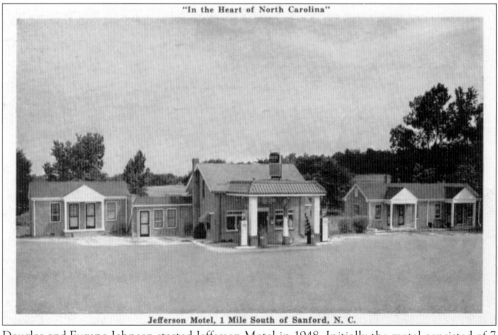

"In the Heart of North Carolina"

Jefferson Motel, 1 Mile South of Sanford, N. C.

Douglas and Eugene Johnson started Jefferson Motel in 1948. Initially the motel consisted of 7 rooms, but it expanded to 14 rooms. Room rent in 1948 was $7 per night. It was located just south of Buffalo Presbyterian Church. (From the collection of W. W. Seymour Jr.)

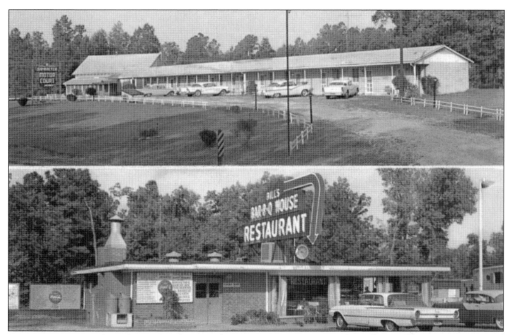

It was not unusual in the 1950s for motels to issue joint postcards with nearby restaurants, and this card shows Sir Walter Motor Court and Bill's Barbecue House. The businesses were located at the current intersection of Hawkins Avenue and Deep River Road. The roads were formerly U.S. Highway 1. (From the collection of W. W. Seymour Jr.)

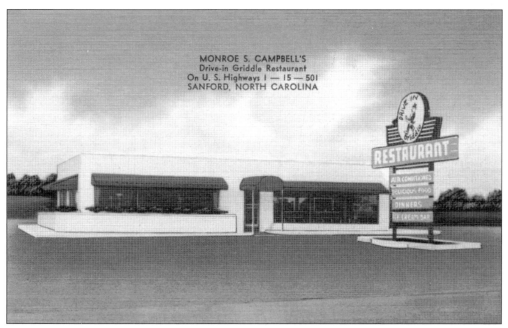

Monroe S. Campbell's drive-in was expanded to a full restaurant in the early 1950s. After the restaurant closed, the building became the office of Raeford Trucking Company. (From the collection of W. W. Seymour Jr.)

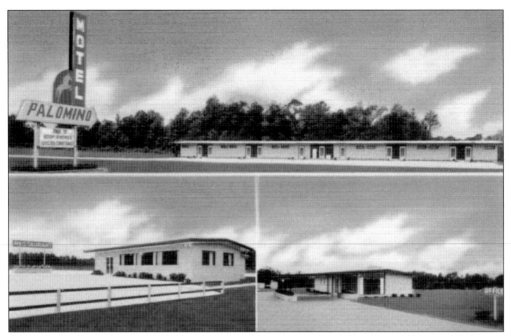

After the Sanford bypass of U.S. Highway 1 had been completed, Douglas and Virginia Johnson built the Palomino Motel and Restaurant on the new highway in 1959. The facility soon began to cater to traveling golfers and continues to be a successful hostelry. (From the collection of W. W. Seymour Jr.)

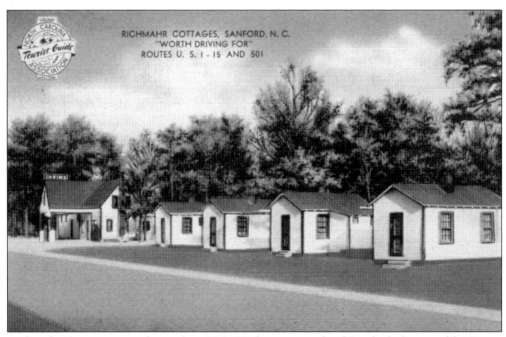

Richmahr Cottages were located on U.S. Highway 1 south of Sanford. Operated by Bruce Cummings for a number of years, the restaurant there was known for good food. (From the collection of Jimmy Haire.)

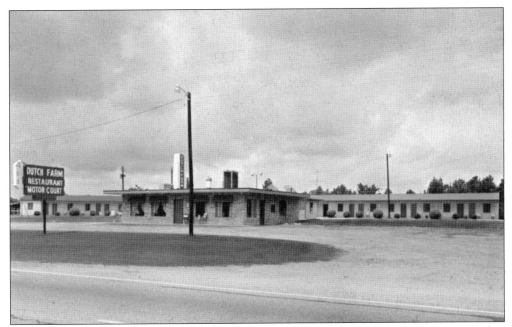

Originally known as Harold's Motel, the Dutch Farm Motor Court and Restaurant was a familiar sight for motorists on U.S. Highway 1 south of Sanford in the 1950s and 1960s. The motel is currently operating under a different name. (From the collection of W. W. Seymour Jr.)

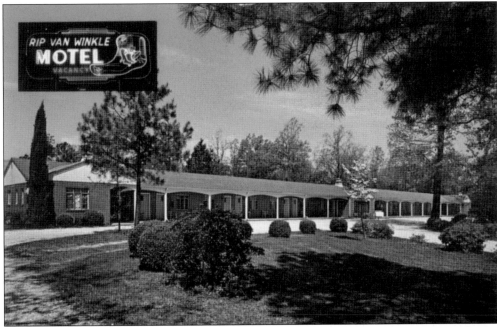

After World War II, Americans took to the highways for their vacations. Most of the motels that popped up beside the major highways were family-owned establishments with unique names. The Rip Van Winkle Motel falls into that category. It exists today on U.S. Highway 1 under a different name. (From the collection of W. W. Seymour Jr.)

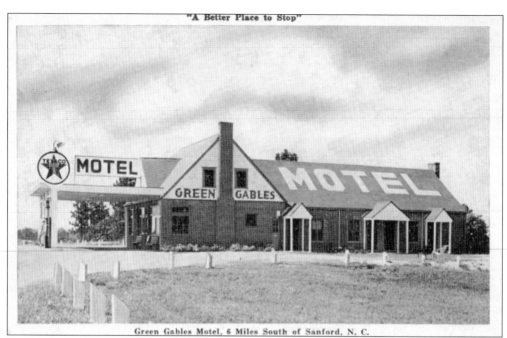

Green Gables Motel, 6 Miles South of Sanford, N. C.

Green Gables Motel was a familiar sight for U.S. Highway 1 travelers for decades. Located at the place where U.S. Highway 15-501 branched off toward Carthage, it was operated for a number of years by Mr. and Mrs. Herman C. Andrews. (From the collection of Jimmy Haire.)

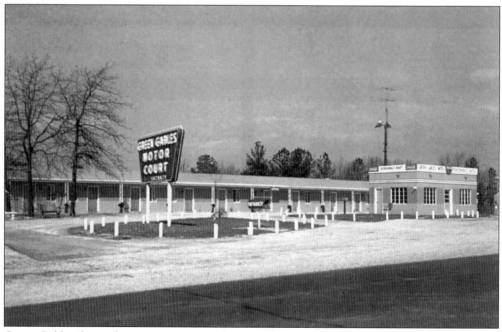

Green Gables changed its appearance over the years. Leon and Sarah Holt operated the motel from 1975 until it closed in 1987. It was demolished in the late 20th century. (From the collection of W. W. Seymour Jr.)

114

Seven

SANFORD'S NEIGHBORS IN LEE COUNTY

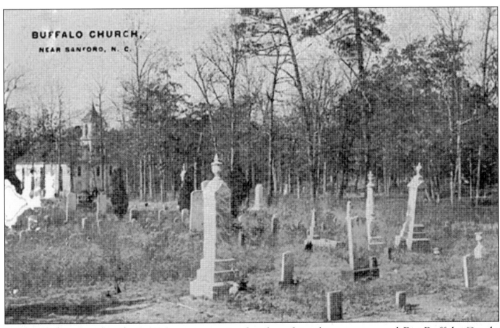

In the 18th century, the Buffalo community developed in the area around Big Buffalo Creek. Jonesboro and Sanford would be settled nearby in the 1860s and 1870s. The Buffalo community would remain a neighbor to these towns until it was annexed into Sanford in 1976. This postcard is from around 1908. (Courtesy of James Vann Comer.)

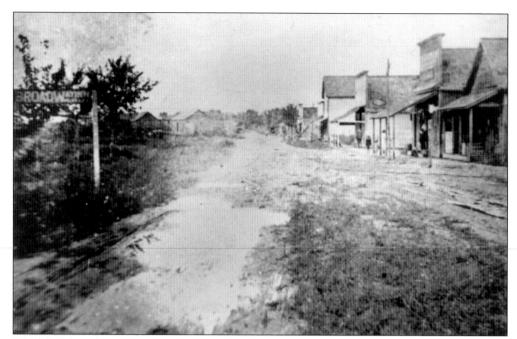

In 1870, a "broad expanse of sand in the midst of tall pine forests" became a place called Broadway, according to a local historical marker. The town charter of Broadway was signed March 8, 1907. This photograph of Main Street looking north was taken during that period. (From the collection of the Railroad House Historical Association.)

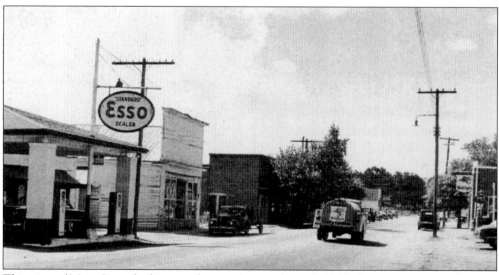

This view of Main Street looking south was taken in the early 1950s. In many respects, the view has not changed much in the past 50 years. (From the collection of Jimmy Haire.)

D. E. Shaw was the founder and first cashier of the Bank of Broadway. Shaw is seen standing in front of the first, 1909 bank building. The Bank of Broadway was the only bank in the area that did not fail during the Great Depression. (Courtesy of Branch Banking and Trust Company.)

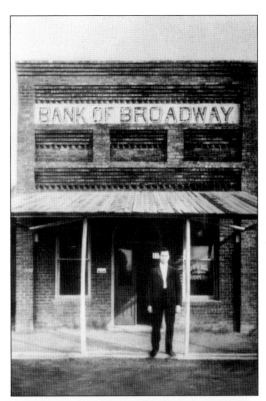

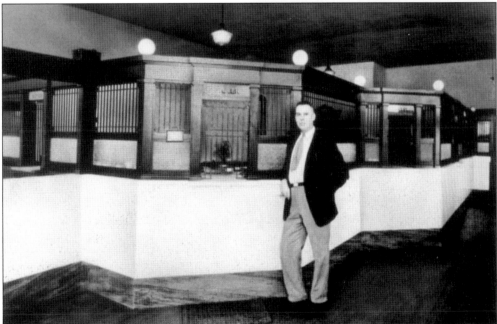

D. E. Shaw is pictured standing in the second building of the Bank of Broadway. It was located across Main Street from the first bank building. This second building is now the Broadway Town Hall. The Bank of Broadway later became the Carolina Bank, and the latter bank later merged into Branch Banking and Trust Company. (Courtesy of Branch Banking and Trust Company.)

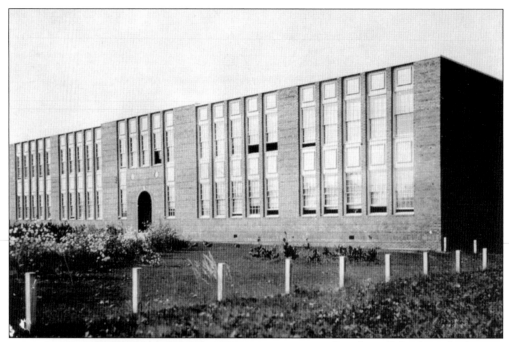

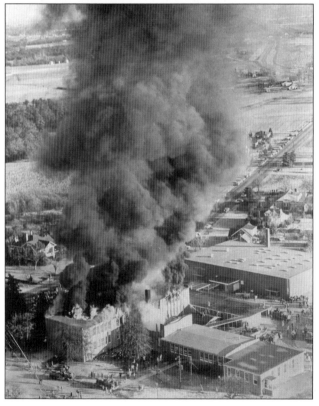

Broadway School was built on Main Street in 1926 and was the pride of the community. On January 3, 1963, a fire destroyed the main school building. It was the first day of classes after Christmas vacation, and many of the students lost Christmas gifts they had brought for show-and-tell. Only three days of classes were cancelled, and a new school was built at the same site. (Top photograph courtesy of Sharon H. Cox; bottom photograph from the collection of Jimmy Haire.)

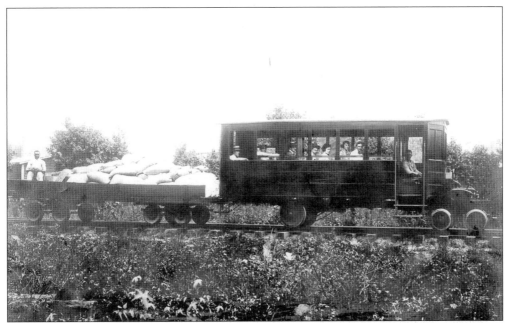

The A&W extended its service to Broadway in 1907, and by 1913, service had been extended to Lillington. Passenger service on the Dinky continued to 1948. This photograph shows the first Edwards motor car on one of its runs. (From the collection of the Railroad House Historical Association.)

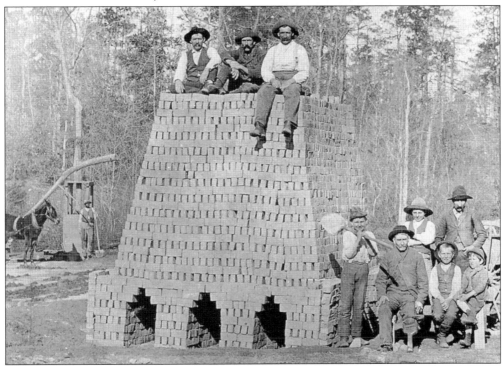

Although the brick manufacturing industry in Lee County was centered in the Colon area, this small skove kiln was located near Broadway. The beehive kiln had a capacity of approximately 5,000 bricks. (From the collection of Jimmy Haire.)

In the early 1850s, the village of Carbonton came into being, and Cyrus Harrington established the Carbonton Academy. The girls' dormitory for the academy was constructed 1853–1854 and is pictured here in an early-20th-century photograph. (From the collection of the Railroad House Historical Association.)

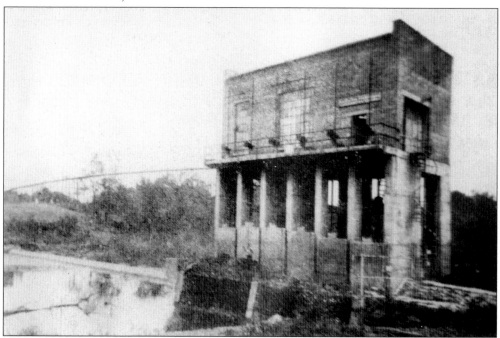

The town of Carbonton is located on the Deep River. The Carbonton Dam was built in 1921 and was operated by Carolina Power and Light Company for approximately 75 years. The dam has been sold and was demolished. (Courtesy of Stella Mashburn.)

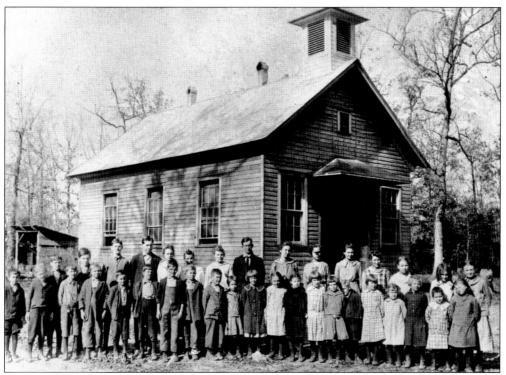

Rose Budd School was named for the daughter of Dr. Abram Van Wyck Budd, the physician for the Egypt mine. It was located one mile northeast of Deep River School and a quarter-mile east of U.S. Highway 1. This 1917 photograph shows the second Rose Budd School's students. (From the Hal Tysinger collection of the Railroad House Historical Association.)

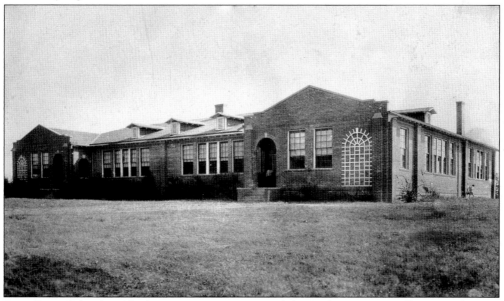

Deep River School was built in 1923–1924 on part of the Bridges property off U.S. Highway 1. The school served the community until the 1990s, when a new school was built on the property. (From the Hal Tysinger collection of the Railroad House Historical Association.)

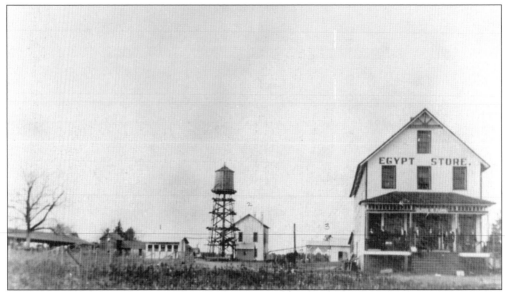

This view of the town of Egypt (Cumnock) is from the early 20th century. Local leader John H. Kennedy, the father of Harvey Kennedy, operated Egypt Store. A sign over the door says "Oliver Plows." The town's name was changed as a result of mine disasters. Cumnock was a mining town in Scotland. (From the collection of Jimmy Haire.)

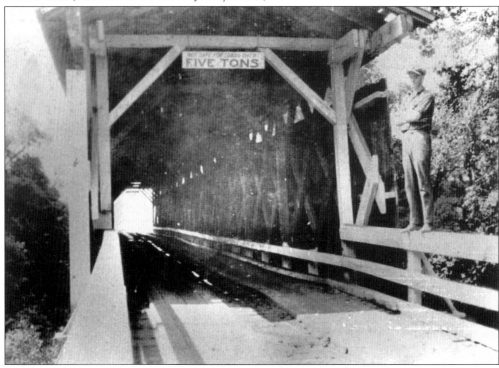

The covered bridge at Cumnock is pictured here. It was destroyed by fire in 1930. Soon thereafter, John H. Kennedy moved one span of a steel camelback bridge to the location over the Deep River. That one-lane bridge was used until the late 1990s, and it is now part of a park located next to a new bridge. (Courtesy of Lois Burns.)

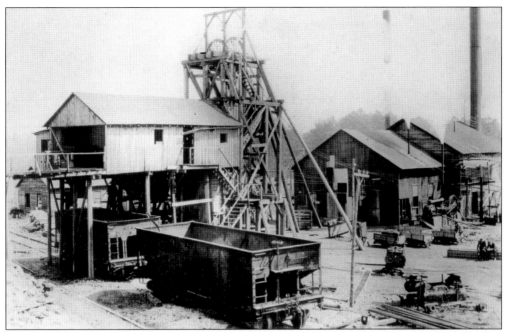

The outside of the mine at Cumnock is shown here. The mine operated from 1855 to the late 1920s. Mine disasters in 1855, 1895, and 1900 resulted in the loss of life. Another mine was operating across the Deep River from Cumnock in Chatham County. (From the collection of the Railroad House Historical Association.)

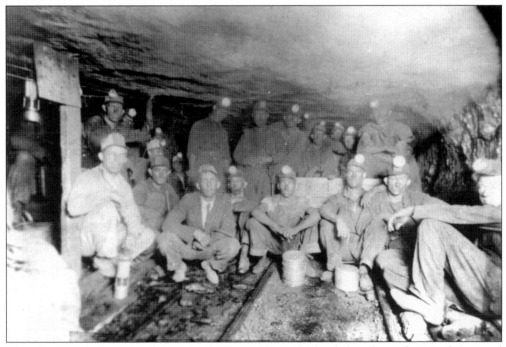

This photograph shows lunch hour in the Egypt Mine 400 feet below the surface. Both Leonard Ascough and his father were coal miners. It was a dirty and dangerous job, but the miners were a dedicated group of workers. (From the collection of the Railroad House Historical Association.)

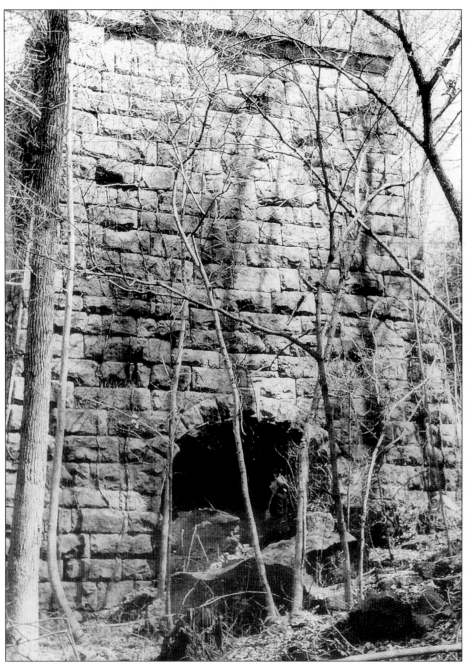

The Endor Iron Furnace, pictured here about 1970, is Lee County's most notable historic site. The furnace was built in 1862 to produce pig iron for the Confederacy. John and Donald MacRae of Wilmington financed the venture. The trapezoidal-shaped stack, built near the bank of the Deep River, was finely crafted of brownstone mined just upstream of the site. Many of the hewn stones in the massive 35-foot-tall structure weigh over 1,000 pounds. The business changed hands several times and was closed about 1873. The property is now owned by the State of North Carolina, and a group spearheaded by the Railroad House Historical Association is raising money to restore the furnace. (From the collection of the Railroad House Historical Association.)

The town of Lemon Springs is located several miles from the spring and resort for which it was named. The town features a number of interesting older buildings, including the Ferguson General Merchandise Store. The Richard Ferguson family came to Lemon Springs in 1924 and ran this store until the early 1980s. (Courtesy of Frances Warner.)

Greenwood School is located in Lemon Springs. The school pictured here was constructed in 1929. A new school replaced it at the same site in the late 1980s. (From the collection of Jimmy Haire.)

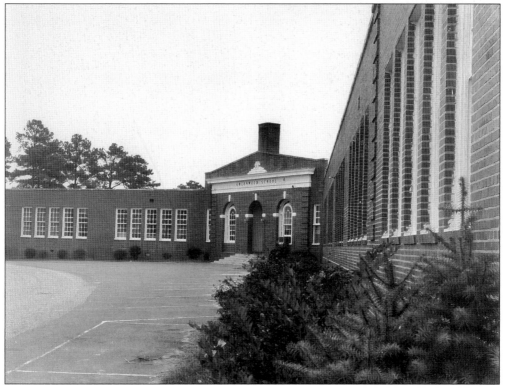

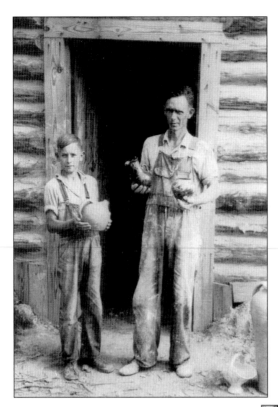

Arthur R. Cole, a famous local potter, is pictured here with his son Foster in 1937. Seagrove native Cole came to Lee County to work at Rainbow Pottery, but he soon established his own pottery. Foster Cole also became a potter. (Courtesy of Neolia Cole Perkinson.)

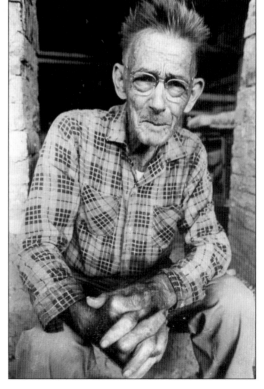

This photograph is a Jimmy Haire portrait of Arthur R. Cole in his later years. Cole's pottery was located on U.S. Highway 1 so that he could sell his pottery to travelers. The new U.S. Highway 1 bypass forced him to relocate to a site further down Hawkins Avenue. The old site now has the southbound exit ramp of U.S. Highway 1 at Hawkins Avenue crossing it. Cole died in 1974. (From the collection of Jimmy Haire.)

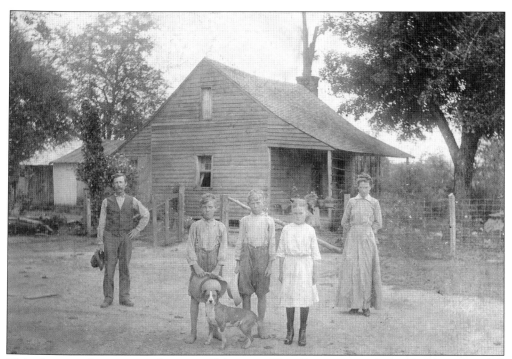

This photograph gives an indication of life in rural Lee County around 1914. It shows, from left to right, C. T. White, his children Aubrey, Bill, and Jessie, and his wife, Betty. Aubrey White was to be mayor of Sanford from 1951 to 1953. (From the collection of Jimmy Haire.)

The Lee Drive-In Theatre opened on March 2, 1951. It was located on Highway 87 South, near the car dealerships. The Lee was one of several drive-ins in the county during the 1950s and 1960s. (From the collection of Jimmy Haire.)

ACROSS AMERICA, PEOPLE ARE DISCOVERING SOMETHING WONDERFUL. *THEIR HERITAGE.*

Arcadia Publishing is the leading local history publisher in the United States. With more than 3,000 titles in print and hundreds of new titles released every year, Arcadia has extensive specialized experience chronicling the history of communities and celebrating America's hidden stories, bringing to life the people, places, and events from the past. To discover the history of other communities across the nation, please visit:

www.arcadiapublishing.com

Customized search tools allow you to find regional history books about the town where you grew up, the cities where your friends and family live, the town where your parents met, or even that retirement spot you've been dreaming about.